COLOR
HARMONIES

AUGUSTO GARAU

COLOR HARMONIES

TRANSLATED BY

Nicola Bruno

WITH A FOREWORD BY

Rudolf Arnheim

THE UNIVERSITY OF CHICAGO PRESS

Chicago & London

Augusto Garau teaches color theory and psychology
of form at the Polytechnic Design Institute of Milan.
His paintings have been shown in numerous exhibitions
in Italy and abroad.

Nicola Bruno is a lecturer in the Department of
Psychology at the University of Trieste.

Rudolf Arnheim is professor of art history emeritus
at the University of Michigan.

The University of Chicago Press, *Chicago 60637*
The University of Chicago Press, Ltd., *London*
© 1993 by The University of Chicago
All rights reserved. Published 1993
Printed in the United States of America
02 01 00 99 98 97 96 95 94 93 5 4 3 2 1

ISBN (cloth): 0-226-28195-7
ISBN (paper): 0-226-28196-5

Originally published as *Le armonie del colore,*
© 1984 Giangiacomo Feltrinelli Editore, Milan.

Library of Congress Cataloging-in-Publication Data

Garau, Augusto.
 [Armonie del colore. English]
 Color harmonies / Augusto Garau ; translated by Nicola
Bruno ; with a foreword by Rudolf Arnheim.
 p. cm.
 Includes bibliographical references.
 ISBN 0-226-28195-7. — ISBN 0-226-28196-5 (pbk.)
 1. Color—Psychological aspects. 2. Harmony (Aesthetics)
I. Title.
ND1495.P8G3713 1993
701'.85—dc20 92-17710
 CIP

This book is printed on acid-free paper.

CONTENTS

FOREWORD

IT IS INSTRUCTIVE to look at the history of Western art in light of the relation between the two great antagonists and allies—shape and color. Ever since the Florentine painters of the Renaissance, who based their style on neatly defined shape, contended with the Venetians, whose compositions depended so heavily on color relations, each generation of painters has had to settle for a particular ratio between the two aspects of pictorial form. The variations of style characterizing the history of Western art through the centuries have been strongly determined by their emphasis on either shape or color.

It is true that as long as narrative representation dominated the arts as their primary purpose, shape tended to have the upper hand because of its superior ability to distinguish things. Consider only the art of portraiture, where an infinity of highly articulate shapes lets painters define the individual likeness of persons. Shades of color all by themselves barely allow us to tell water from foliage and would certainly fail us if we wanted to rely on them for telling the portrait of Mona Lisa from one of Napoleon.

Generally speaking, color can hardly manage without the help of shape, which supplies the framework for the placement of colors, whereas shape can attain high levels of representation and expression all by itself. Consequently, in the writings of art theorists color has often been considered subservient to shape. Intuitively they anticipated the findings of some modern psychologists such as Hermann Rorschach, who associated shape with reasoning and color with emotion. In an age of reason, this put shape in a kingly position. Color was considered the handmaiden of shape; it merely provided a pleasing garment for the essential structure of the image. It was the feminine companion of a masculine ruler. Only with the advent of Romanticism and with the development of colorism as one of the conspicuous stylistic trends of painting in the nineteenth and twentieth centuries did the problems of color begin to be admitted to serious theoretical discussion.

It remains true, however, that the serious study of color, as compared with that of shape, faces almost insurmountable difficulties. We know the exact shapes used by Greek painters for the figures on their vases over two thousand years ago, whereas the pigments of as recent a painter as Van Gogh have already changed color. Anyone privileged to view the restorations in progress in the Sistine chapel in Rome has witnessed Michelangelo's lively greens and blues reemerging miraculously from the thick layers of grime and irresponsible retouching that have obscured them for centuries. Similarly, scholars can use

reproductions of paintings to study shapes fairly reliably, whereas color can be investigated only by direct inspection of the originals. A study of subtle nuances, such as the ones offered in this book, depends on the faithful rendering of the illustrations.

Nevertheless, a respectable literature on color problems exists. It concerns, first of all, the optical, chemical, and physiological factors determining the production and perception of colors. Anthropologists and psychologists have studied the selection of, and preference for, particular colors under given cultural conditions. Historians have investigated the various forms of symbolism by which colors have been related to religious and social conventions. More particularly, we have learned much about the color schemes adopted by artists in different periods and their techniques for applying them to the various tasks of the painter.

Closer to what may be called the perceptual or phenomenological aspects of color theory are two problems, namely, expression and structural organization. This book is devoted to the latter subject, but the former needs to be mentioned here briefly. Expression concerns the ability of colors to offer perceptual equivalents of what are often described as emotional states. The German expressionists of the twentieth century have referred explicitly to this power of pictorial color. I will limit myself to one quotation, taken from the memoirs of Emil Nolde, in which he refers to the screams of pain uttered by hares that were captured in traps or attacked by weasels. Those screams obsessed the painter's ears, he says, and were soon condensed to colors symbolizing the cruel nature of animal life, "the shrieking yellow of the screams and the dark violet of the hooting owls." Attempts to associate colors with specific forms of expression have been made by many writers, notably Goethe and Kandinsky, but there is little general agreement on the subject.

The same is true for a basic feature of pictorial expression, namely, the difference between warm and cold colors. I mention it here because there is some evidence to support a suggestion of mine that the temperature quality of colors is determined not so much by the dominant hues as by subordinates in tertiary colors, which play such a prominent role in this book. Johannes Itten in his treatise on the art of color identifies the "poles of cold and warm" as blue green and red orange, and Augusto Garau has dealt with the problem in recent experiments derived form those he describes here; he, too, finds that the tertiary hues are crucial for the determination of color temperature.

Of more central importance for the painter's work is structural organization. This has always been obvious for the composition of shape, while much less attention has been paid theoretically to the corresponding problem of color. Organization creates order and, as Matisse has said, "to put the colors in order means to put order in the ideas." In his *Notes d'un peintre,* Matisse explains that when colors are combined in a painting they "diminish one another." He says that "the different marks [*signes*] I employ must be balanced in such a way that they do not destroy one another."

What, however, are the properties that make it possible for colors to interrelate and thereby to create order or disorder? Essentially, they are relations between hues, just as musical structure depends largely on the pitch relations between tones. And just as to understand tonal music one has to be aware of the structure of the scale, it is necessary to understand the system of color relations if the color composition of paintings is to make sense.

Before I refer to the color system on which Augusto Garau's investigation is based, it will be useful to anticipate certain misunderstandings that have often interfered with communication in this area. When it comes to the theory and practice of color relations, there is still a widespread lack of distinction between two problems. One of these problems concerns the question of how the colors we see come about physically or physiologically. The other asks how colors, once they have been produced in whatever manner and exposed to the eyes, behave phenomenally when they are viewed in their interrelation, for example, in pictorial composition. The first problem deals with the chemistry of pigment mixtures and the physical optics of color analysis and color combination. It also deals with the physiological mechanisms by which the eyes and the nervous system record and process light stimuli. It is an approach that studies receptor mechanisms, afterimages, contrast, color fusion, and so forth. The second problem has nothing to do with how colors come about. Whether produced by pigments or lights and whether these are mixed or unmixed, the resulting colors are taken as given and observed as to how they behave when they are organized in patterns. This problem concerns the painter and designer as composer, and it is this which is the subject of Garau's book.

Another related but more limited issue has created considerable controversy. It is the question of how many primary or fundamental colors there are, and specifically whether green should be added to the ranks of red, yellow, and blue. This debate has nothing to do with how many and which colors are

needed to generate the total range of colors. Nor are we asking by what physical or physiological means the color green comes about. The question is exclusively: Once I see green, what do I see—a pure color or a combination of two primaries, blue and yellow? In his influential book on the theory of the light sense, Ewald Hering asserted that green was a primary color. He had worked out a physiological theory of the reception of light stimuli based on the interaction of two pairs of antagonistic receptors, green versus red and blue versus yellow. This mechanism led him to propose by analogy that a similar system of four fundamental elements governs color perception. It is important to recognize that this is an entirely phenomenological matter. When Hering maintains that "no color is both yellowish and bluish at the same time," the statement is based on no other authority than what he says his eyes told him. A physiological mechanism of how colors come about does not prescribe the appearance of what is perceived. It is true that recent studies of the Italian psychologist Osvaldo da Pos have shown that under certain experimental conditions subjects report being unable to discern elements of blue and yellow in the color green. Weightier, however, is the historical fact that the assertion made by Hering and his followers is opposed by the majority of painters, who can be expected to know something about how colors look and who, from Philip Otto Runge and Delacroix to Paul Klee and Johannes Itten, have based their color systems on red, blue, and yellow as the pure primaries. Garau's book follows this well-established pictorial tradition.

For the exploration of principles it is useful to work with a system that contains neither too few nor too many colors. A circle of twelve hues, first proposed by Paul Klee and Johannes Itten, suffices to describe the phenomena discussed in this book (fig. 1). The system subdivides into the following three hierarchical levels:

1. The three primaries, red, blue, and yellow, which are pure hues and therefore unrelatable to one another, except by their adding up to a complementary triad. The realm of each primary reaches around half of the color circle.

2. The three secondaries, violet (BR), orange (RY), and green (YB), each of which consists of two of the primaries and therefore creates a bridge between them. The two components are balanced, in the sense that their pull toward the primaries is equally strong in both directions.

3. The tertiaries, each of which is located between a primary and a second-

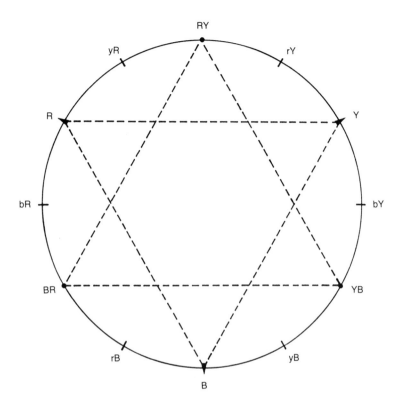

Figure 1. Circle of 12 hues, developed by Paul Klee and Johannes Itten.

ary color. An unequal ratio results between the two components, for example, bluish red or reddish yellow. Being thus unbalanced, tertiaries are highly dynamic, prone to interact with other colors and, for this reason, particularly inviting for pictorial composition. In some ways they resemble the "leading tones" in music. They are perceived as approaches to and deviations from their stronger component. Thus a reddish blue strains toward the stable base of the pure blue or, conversely, tries to liberate itself by pulling away from that base.

The structural organization of colors relies essentially on connections and segregations, just as a human or animal body is structured by its joints, tendons, and muscles. The simplest principle serving this purpose is that of similarity and dissimilarity. Viewers see connections between similarly colored areas of a painting, even when these are at a distance from one another, and they see dissimilar areas as detached, even when they border on each other.

A more complex structural relationship is created by complementarity. Perceptually, colors are complementary when, together, they contain all three pri-

maries in equal proportion. Thus the three primaries themselves form a complementary triad. In the color circle of figure 1, colors are arranged in such a way that all opposite pairs are complementaries. There are three pairs formed by a primary and a secondary, for example, blue (B) and orange (YR), and three formed by tertiaries, for example, bluish yellow (bY) and bluish red (bR). Complementarity makes for a curiously ambivalent relationship. Since the paired colors complete each other, they are attracted to each other by a kind of visual magnetism. On the other hand, however, they can also be mutually exclusive, as, for example, when a red is set against a green, in which case attraction is counteracted by detachment.

In an even subtler way, structural organization is based on the relative weight of the primaries in tertiary mixtures. This makes for connections and segregations, to which much of *Color Harmonies* is devoted. As a preparation fore Garau's own demonstration in plates 11–14 I offer figure 2, where white, shading, and black stand for the three primaries. The quantitative relationship between dominant and subordinate color in each tertiary mixture is given the arbitrary ratio of 2 : 1.

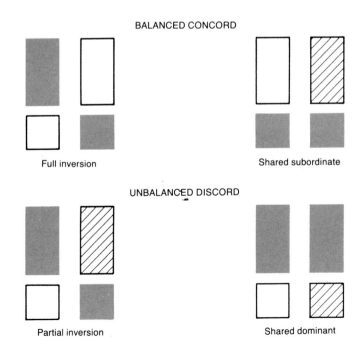

Figure 2. Structural organization based on relative weight of primaries in tertiary mixtures (ratio of dominant to subordinate in tertiary mixtures arbitrarily set at 2:1).

Full inversion can be obtained when only two primaries are involved. By combining them in inverse ratio—for instance, a bluish red (bR) and a reddish blue (rB)—the two tertiary colors are symmetrically related to the same secondary color, in this case violet (RB). This makes for two closely interrelated colors, which form a bridge between the two primaries, in this case red and blue. Structurally this relationship produces concord.

The relationship is less simple when all three primaries are at play. *Partial inversion* prevails when the share of one of the primaries is inverted and combined with the other two. This produces an asymmetrical combination, for example a yellowish red (yR) and a reddish blue (rB). The result is a distinctly discordant clash between two unbalanced tertiary combinations. A similar effect of detachment is obtained by a *shared dominant*, for example, by the combination of a yellowish red (yR) with a bluish red (bR). It is as though two neighbors were torn in different directions, causing considerable tension. In the opposite case, however, a *shared subordinate* makes for complementarity, already mentioned above. A bluish yellow (bY) and a bluish red (bR) add up to equal weights for all three primaries, covering the full range of the color system—the strongest bond available between colors.

The principles thus far discussed refer to color relations in the pictorial plane. Together with the structural relations between shapes, they enable the artist to articulate a composition. The simplest of these principles—the distinction between similarity and dissimilarity—was used by medieval painters to combine and separate elements of their compositions. At times they may consciously have resorted also to concord and discord for the same purpose. Garau uses a few examples of recent paintings to show how artists rely on the organization of color, just as they rely on shape, to translate intended meaning into visual form.

Perceptual segregation can also be applied in the third spatial dimension, that is, in pictorial depth. This involves the spatial features of overlapping and transparency. Gestalt psychologists showed many years ago that perceptual transparency occurs when the tendency toward simplest structure causes a pattern of shapes to be seen as a combination of elements overlapping in depth rather than bordering contiguously on each other (pls. 43, 44). The resulting superposition of shapes forces the shared area to split up into two planes, one of which is perceived as lying in front of the other. When the planes are in black and shades of gray, the brightness value of the shared area should equal

the arithmetic means of the luminosities in the contributing areas. The conditions to be met when patterns are in color are more complex. Here Garau has done pioneering work by applying the principles of structural concord and discord to the conditions producing transparency.

I have tried to set the stage for Augusto Garau's report on his ingenious experiments. If I may be permitted to add a personal comment, I would like to say how delighted I was to learn that the author, who combines experience as an artist, designer, and art educator with the ability to conduct systematic research, was willing to test experimentally some of the principles I had developed earlier from mere intuition. In an area of the psychology of art where reliable guidance is still so hard to come by, these well-supported contributions to the theory of color composition ought to be welcomed by practitioners and scholars alike.

RUDOLF ARNHEIM

PRELIMINARY NOTE

In this book, figures, plates, and text often refer to colors and color mixtures by means of a simplified notation, as follows:

Y = yellow	O = orange (YR)
R = red	G = green (BY)
B = blue	V = violet (RB)

For the tertiary mixtures, uppercase letters refer to dominant colors, and lowercase letters indicate subordinate colors.

bY = bluish yellow	rY = reddish yellow	yB = yellowish blue
bR = bluish red	yR = yellowish red	rB = reddish blue

ACKNOWLEDGMENTS

I am indebted to Silvia Ceste, Stefania Chiesa, Elena Fraternali, Carlotta Grandi, Silvia Iazzarelli, and Paola Lucarelli, students at the Polytechnic School of Design, for executing the color drawings in this book, and to Paola Tarocchi for editing them for reproduction in the color plates.

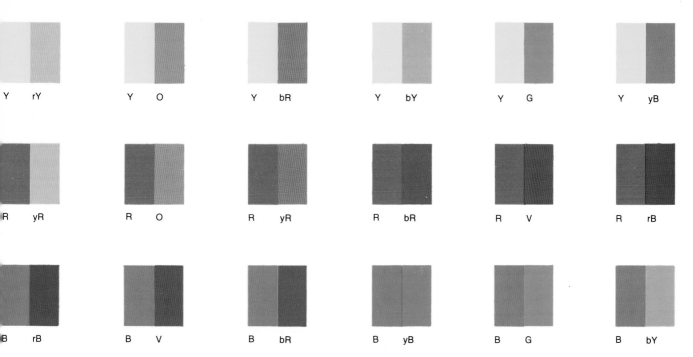

Plate 1. Juxtapositions of a primary color with the mixtures that contain that primary.

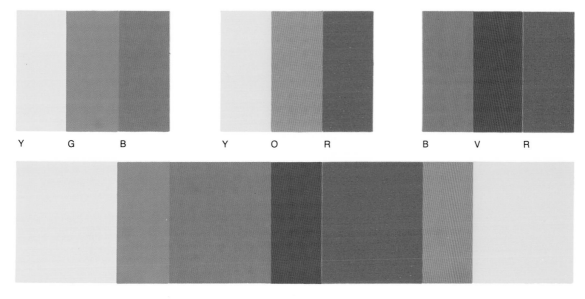

Plate 2. The three secondary mixtures placed between the two primaries employed to form them.

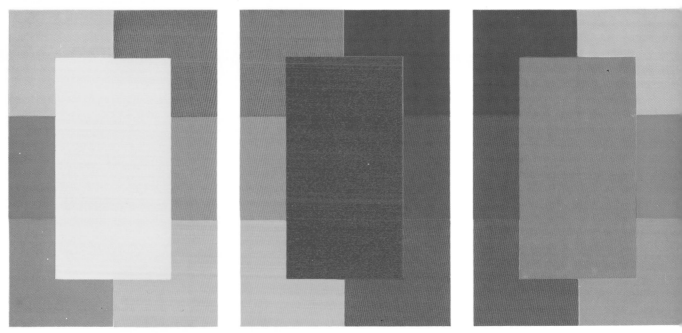

Plate 3. The three primaries surrounded by their mixtures.

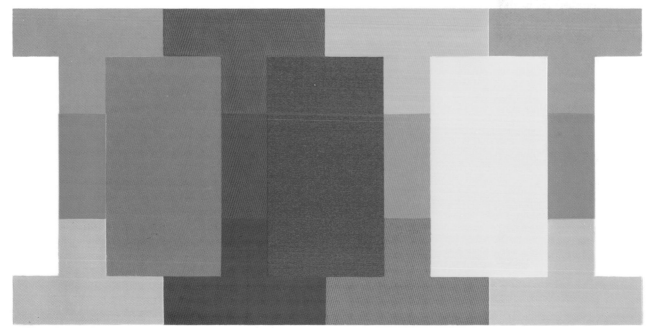

Plate 4. Chromatic continuum.

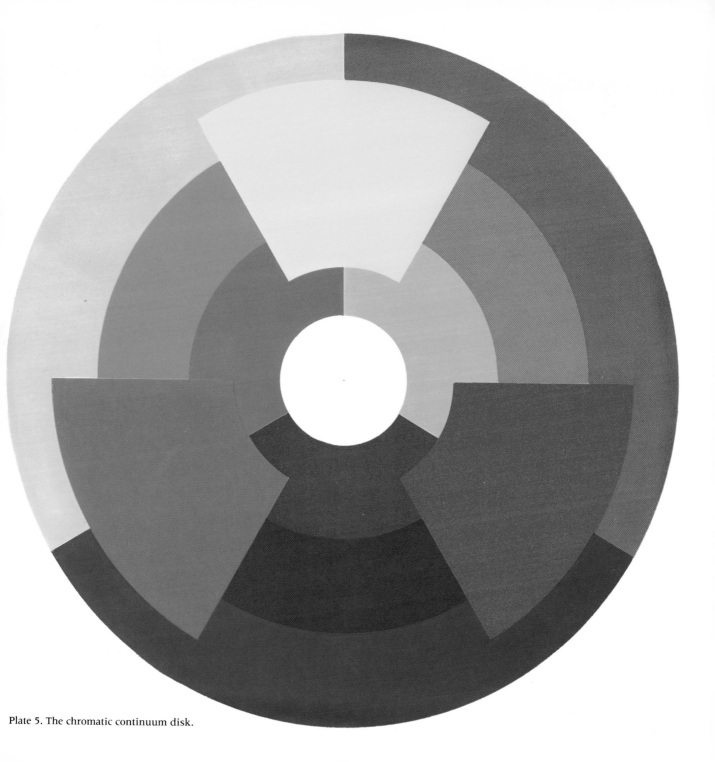

Plate 5. The chromatic continuum disk.

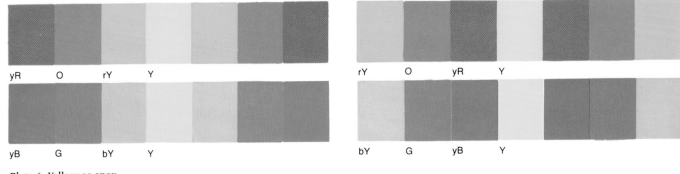

yR O rY Y

yB G bY Y

rY O yR Y

bY G yB Y

Plate 6. Yellow as apex.

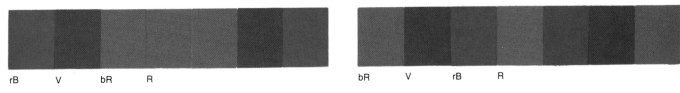

rB V bR R

bR V rB R

Plate 7. Red as apex.

V rB B

rB V B

Plate 8. Blue as apex.

Plate 9.
Work by
Elena
Fraternali.

Plate 10.
Work by
Silvia
Iazzarelli.

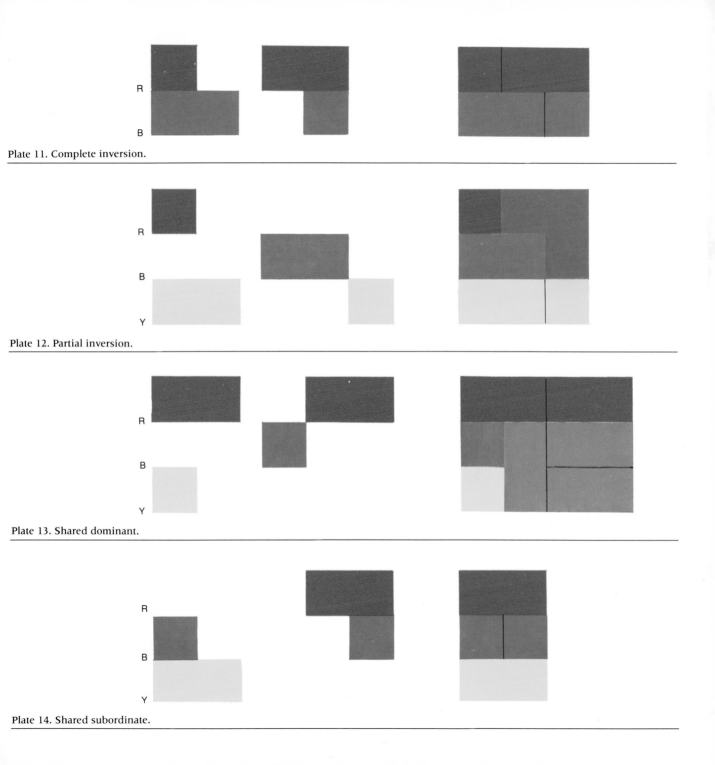

Plate 11. Complete inversion.

Plate 12. Partial inversion.

Plate 13. Shared dominant.

Plate 14. Shared subordinate.

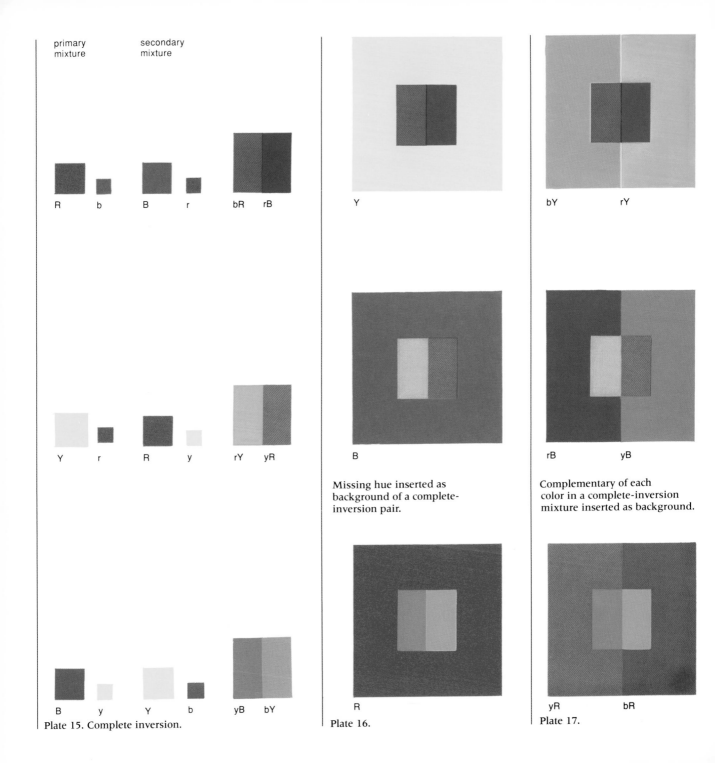

primary
mixture

secondary
mixture

R b B r bR rB

Y r R y rY yR

B y Y b yB bY

Plate 15. Complete inversion.

Y

B

R

Missing hue inserted as
background of a complete-
inversion pair.

Plate 16.

bY rY

rB yB

Complementary of each
color in a complete-inversion
mixture inserted as background.

yR bR

Plate 17.

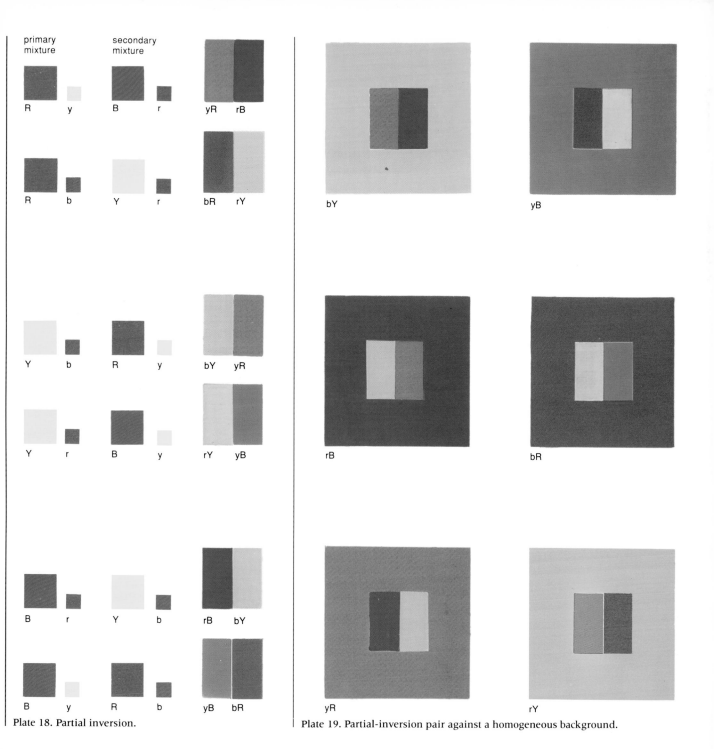

Plate 18. Partial inversion.

Plate 19. Partial-inversion pair against a homogeneous background.

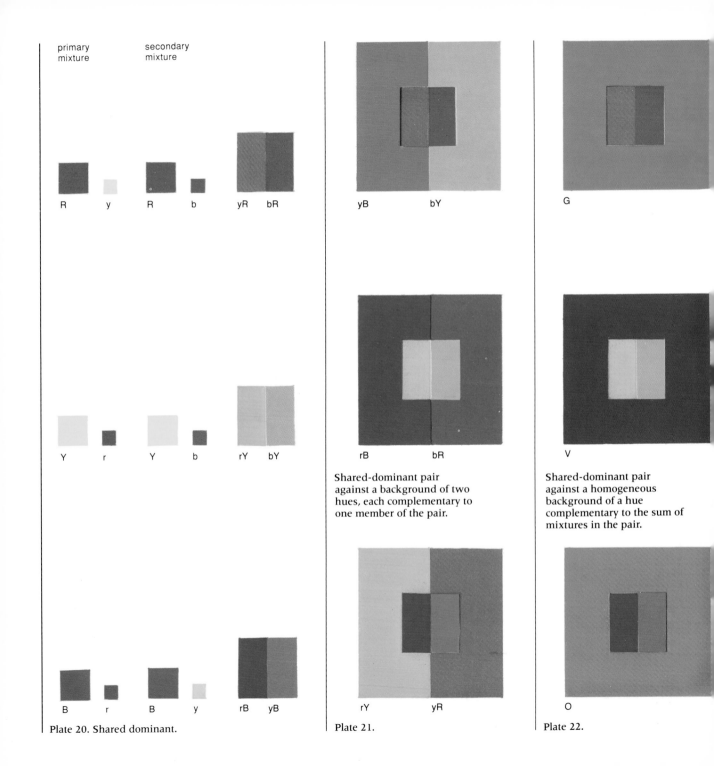

primary
mixture

secondary
mixture

R y R b yR bR

Y r Y b rY bY

B r B y rB yB

Plate 20. Shared dominant.

yB bY

rB bR

Shared-dominant pair
against a background of two
hues, each complementary to
one member of the pair.

rY yR

Plate 21.

G

V

Shared-dominant pair
against a homogeneous
background of a hue
complementary to the sum of
mixtures in the pair.

O

Plate 22.

primary
mixture

secondary
mixture

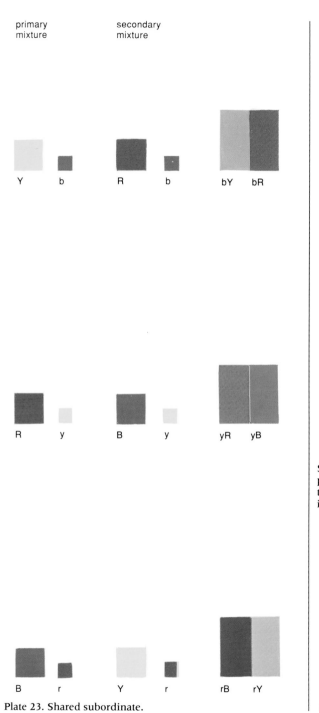

Y b R b bY bR

R y B y yR yB

B r Y r rB rY

Plate 23. Shared subordinate.

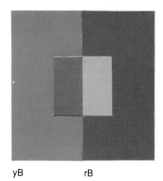

yB rB

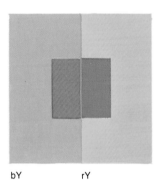

bY rY

Shared-subordinate
pairs against background when
the subordinate color in the pair
is dominant.

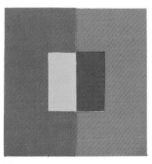

bR yR

Plate 24.

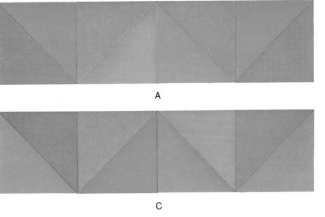

A

B

C

D

Plate 25. Examples of harmonic and disharmonic juxtapositions. In a and d, one readily sees four squares forming two rectangles. The alternative solution, large alternating triangles, is more difficult to see. Within the squares, the small triangles form harmonic chromatic pairs, while between the squares disharmonic juxtapositions are formed. In b and c one tends to see the large alternating triangles composed by smaller triangles, each being one-half of the two adjacent squares. This solution is favored because harmonic pairings are formed. Also in this case, between one large triangle and the other the divisions are attained by means of disharmonic chromatic pairings.

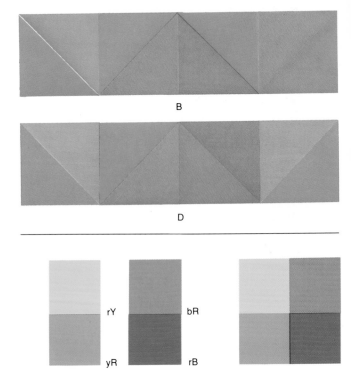

rY bR

yR rB

Plate 27. In plates 26 and 28, the two vertical rectangles on the left are each formed by two squares, each of different color. These rectangles form disharmonic color pairs and therefore cause a diverging tension. If the two rectangles are placed next to each other, as in the squares on the right, horizontal perceptual units are formed. The two vertical rectangles lose their figural unity, and the respective squares are each free to bind with the other square on the same horizontal line, forming a harmonic pairing endowed with a stronger binding force. The opposite takes place in plates 27 and 29, where the rectangles are composed by harmonic pairings which preserve their figural unity even when arranged in a square.

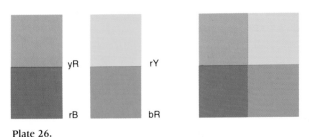

yR rY

rB bR

Plate 26.

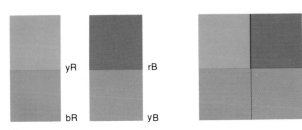

yR rB

bR yB

Plate 29.

yR bR

rB yB

Plate 28.

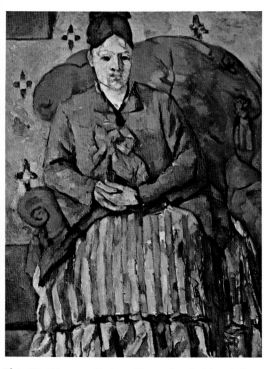

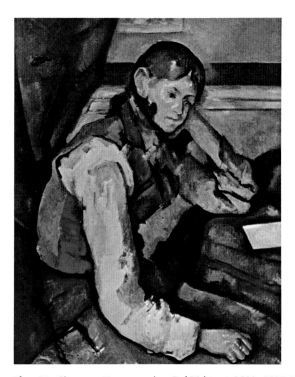

Plate 30. Cézanne, *Madame Cézanne in a Red Armchair,* ca. 1877 (72.5 × 56 cm). Museum of Fine Arts, Boston.

Plate 31. Cèzanne, *Young man in a Red Waistcoat,* 1890–1895 (92 × 73 cm). Bührle Collection, Zurich.

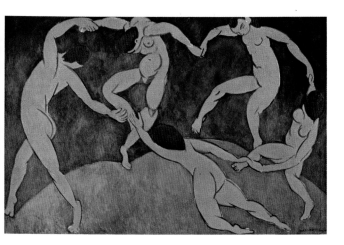

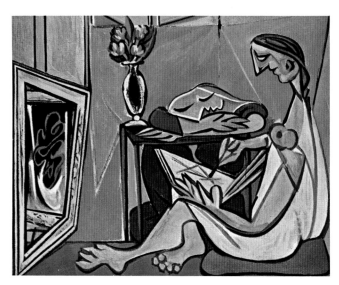

Plate 32. Matisse, *The Dance,* 1910. (260 × 391 cm). Hermitage, St. Petersburg.

Plate 33. Picasso, *The Muse,* 1935 (130 × 162 cm). Musée d'Art Moderne, Paris.

Plate 34. Augusto Garau, *Red Field*, 1983. Oil on canvas (130 × 130 cm).

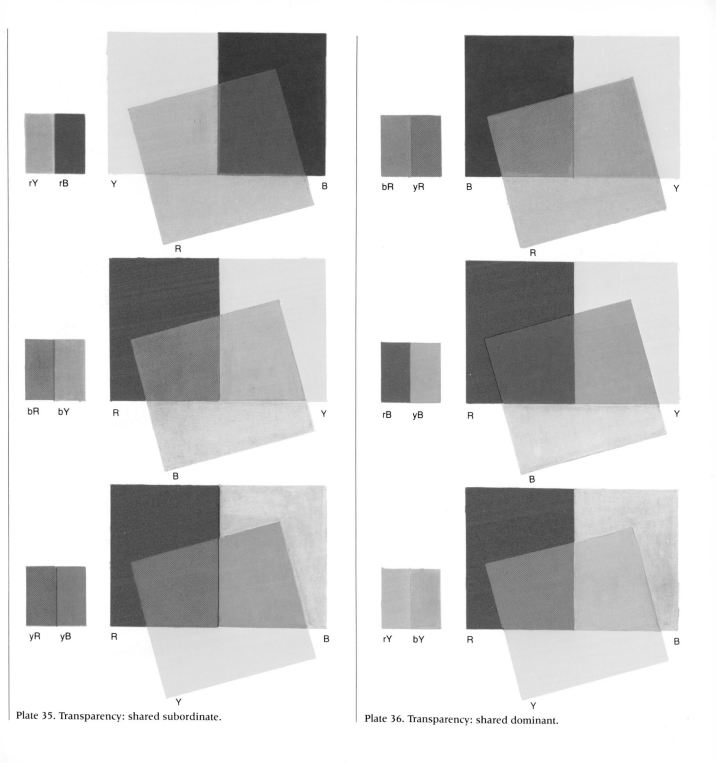

rY rB

Y B

R

bR bY

R Y

B

yR yB

R B

Y

bR yR

B Y

R

rB yB

R Y

B

rY bY

R B

Y

Plate 35. Transparency: shared subordinate.

Plate 36. Transparency: shared dominant.

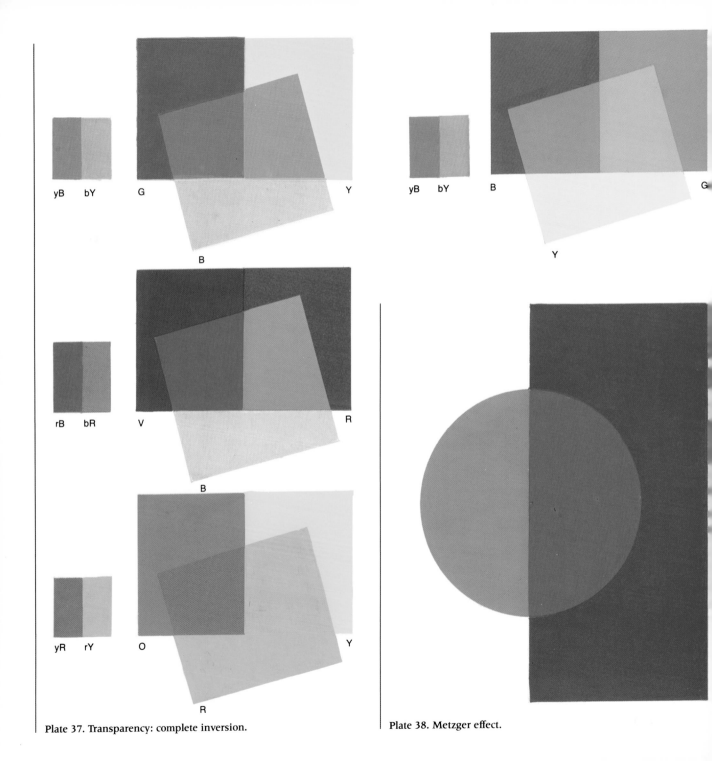

yB bY G Y

B

yB bY B G

Y

rB bR V R

B

yR rY O Y

R

Plate 37. Transparency: complete inversion.

Plate 38. Metzger effect.

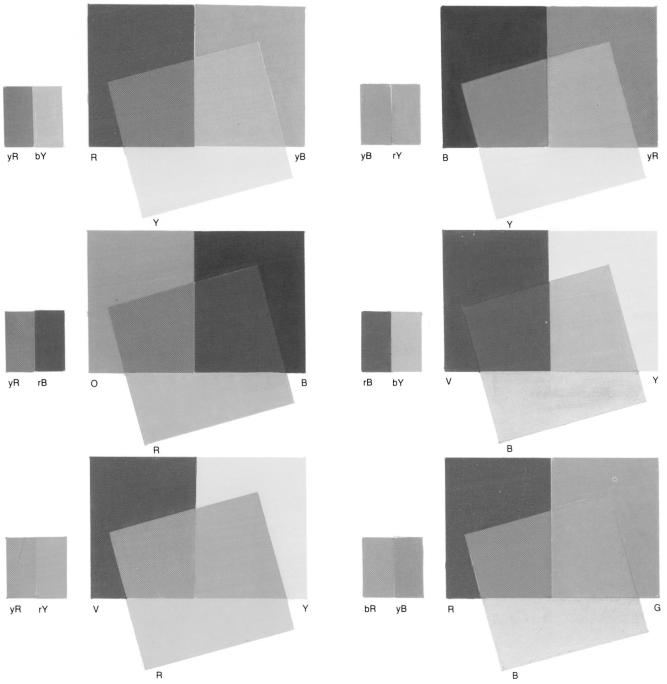

yR bY R yB Y

yB rY B yR Y

yR rB O B R

rB bY V Y B

yR rY V Y R

bR yB R G B

Plate 39. Transparency: partial inversion.

Plate 40. Instances of anomalous transparency.

INTRODUCTION

A Theory of Color Mixtures

THE EXPERIMENTS PRESENTED in this work investigate problems I have encountered during my activity as a painter. The starting point for the experiments was found in some hypotheses and conclusions presented by Rudolf Arnheim when he examined classical theories of color from the viewpoint of their use in painting.

THE SEARCH FOR HARMONY

"How are colors related to one another? Most theorists have dealt with this question as though it meant: Which colors go together harmoniously? They have tried to determine the assortments of colors in which all items blend readily and pleasantly" (Arnheim 1954).

Most color systems have been elaborated along three dimensions, because three are the perceptual dimensions of color. Some of these systems are the pyramid of Lambert, the double cone of Ostwald (1922), and the sphere of Philipp Otto Runge (1810) later adopted by Itten (1965). In the last of these, colors, maximally saturated at the equator of the sphere, are gradually desaturated along horizontal axes, are lightened going upward, and are darkened going downward. This arrangement makes it possible to connect colors in harmonic progressions of triangles and diameters. At the vertexes of the triangles and along the diameters, colors are graduated in hue, brightness, and saturation.

Arnheim observed that harmony is essential, because all colors in a composition must be mutually compatible and must form a unified whole, if they are to be put in relation to one another. Probably, said Arnheim, in most cases colors employed by artists do not agree with rules as simple as those put forward by systems of chromatic harmony.

MUSICAL COMPOSITION

Comparing painting with musical composition, Arnheim turned to Schönberg and his doctrine of music. Describing the subject matter of musical composition, Schönberg (1963) divided it into three areas: harmony, counterpoint, and the theory of form. *Harmony* is the doctrine of the chords and their possible connections with regard to their tectonic, melodic, and rhythmic values, and their relative weights. *Counterpoint* is the doctrine of the movement of voices with regard to motivic combination. The *theory of form* deals with the rules for constructing and developing musical thoughts.

1

"In other words," said Arnheim, "musical theory is not concerned with which sounds go together nicely, but with the problem of giving adequate shape to an intended content. The need for everything to add up to a unified whole is only one aspect of this problem, and it is not satisfied in music by drawing the composition from an assortment of elements that blend smoothly in any combination" (Arnheim 1954, p. 349).

Turning again to pictorial composition, Arnheim observed that compositions need as many separations as they need connections, for if there are no separated parts there is nothing to connect. He noted that Schönberg knew that "the musical scale can serve as the composer's palette precisely because its tones do not all fit together in easy consonance but also provide discords of various degrees" (Arnheim, 1954, p. 350). Arnheim concluded that the traditional theory of color harmony provides only a method for creating connections and avoiding separations. Thus, the traditional theory is at best incomplete.

UNBALANCED MIXTURES (TERTIARY HUES)

Concerning pictorial composition, traditional theories of color focus on the three fundamental primaries, yellow, blue, and red; on their balanced mixtures, green, violet, and orange; and on three pairs of tertiary complementaries, reddish yellow and reddish blue, yellowish red and yellowish blue, bluish yellow and bluish red. When achieved by means of complementaries (as when mixing a primary and a secondary, or two tertiaries), chromatic interactions satisfy a need of the human organism, because our vision needs the presence of the three fundamental primaries either pure or mixed.

These three primaries are completely autonomous, for each shares no chromatic similarity with the other two. Thus, interactions among primaries are only possible by means of the bridging function of secondaries. At the same time, the equal, or balanced, mixture of two primaries sets up a relationship of contrast and of connection with the third color. This relationship binds the three colors dynamically, accomplishing a chromatic completion. "Since the eye spontaneously seeks out and links complementary colors, they are often used to establish connections within a painting between areas that lie at some distance from one another" (Arnheim 1954, p. 360).

Chromatic completions can be obtained by arranging the three pure colors in different areas of the visual field. In some cases, these completions will sat-

isfy the painter. In his last period, Mondrian used only the three primaries in his compositions, arranging them sparsely, and surrounding them with achromatic areas: white, grays, blacks. His choice was meaningful. Starting from the most elementary degree of its use, he strove to treat color as an essential building element of painting. According to Arnheim, the crucial function of color as building element is precisely the weakness of classical theory. If the problem of composition is to establish separations as well as connections, then a theory of color cannot limit itself to chromatic completions and consonances. To develop a theory of color, we also need to ask how to establish negative relationships, capable of articulating the visual field by divisions as well as conjunctions.

Thus, articulation requires tensions of two kinds: diverging and connecting. Both kinds of tension originate from a lack of balance. Both can be used to convey unity to the composition. Arnheim suggested that the capacity of activating tensions is to be found in the tertiary hues, which are unbalanced mixtures of primaries that are present in different quantities.

This peculiar relationship between tertiaries must be distinguished from the interaction of complementary colors that occurs when primaries and secondaries are coupled. The tensions that arise from maximal contrast and from the strong demand for a chromatic completion join complementary colors. Thus, two or three complementaries are quickly united, even if they are in different areas of the field (recall the example of Mondrian). The tensions that arise between pairs of tertiaries, however, are of a different kind. They unfold only when the members of the pair are juxtaposed. Recall that pairs of tertiaries are, for the most part, noncomplementary. This generates univocal, less dialectical relationships than those between pairs of complementaries, for here attraction and contrast no longer coexist. Only one or the other is active.

Still another kind of interaction takes place when one juxtaposes tertiaries containing complementary colors. In this case, the dynamics of attraction and contrast add to the tension between the two asymmetric hues, enriching the relationship. In this way, one can also activate a relationship between a tertiary mixture and a pure color that is contained in it (as with red [R] and reddish yellow [rY]), producing a relationship that is different in kind from that between a primary and a secondary color containing it (as with red [R] and orange [RY]). By the same token, it is different to juxtapose pure red (R) with a mixture that contains it as a subordinate (think of reddish yellow [rY]), or as a dominant (such as yellowish red [yR]). In the latter case, the tension in the

direction of red becomes much stronger. When one juxtaposes two unbalanced mixtures, both hues become dynamic. In the conflict between opposing forces, tensions of different degree and of opposite sign emerge. Both attraction and repulsion result.

The composer-painter can use these opposite tensions to articulate a painting with connections and divisions, just as the composer-musician shapes music with tones that do not all fit together in easy consonance but also provide discords of various degrees.

CHROMATIC CONNECTIONS AND CHROMATIC DIVERGENCIES

I have said already that connections and divergencies are the product of a conflict that takes place between the forces in two contiguous unbalanced mixtures. Because every mixture is composed of two of the three primaries, the conflict is always between four opponents, one of which is present twice. The shared color acts as the pivot for the tensions that arise. It always constitutes a bridge between the two hues, a fact that implies the activation of a connecting force. But it also plays a specific role within each mixture, and this role has a definite influence on the final resolution of the conflict—that is, on the direction and degree of the tensions that emerge.

The shared color may have the same role in the two mixtures—for instance, it may be dominant or subordinate in both—or it may be dominant in one mixture and subordinate in the other.

If the shared color is dominant, then a kind of basic homogeneity is conveyed to the set of the two mixtures. Within this basic homogeneity the other two subordinate colors activate a kind of centrifugal tension. If, on the other hand, the shared color is subordinate, then the two different colors acquire a kind of complementarity, for a third color is added to each of them in the same quantity. These are the kinds of color juxtapositions that Arnheim dubbed "shared dominant" and "shared subordinate" (see fig. 2).

Two other kinds of juxtapositions, dubbed "complete inversion" and "partial inversion" (fig. 2), complete the list of the mixtures investigated by Arnheim. In the first kind, only two colors are present in the mixtures. These colors invert their roles completely, in the sense that each of them is dominant in one mixture and subordinate in the other. The result is a tension toward a common equilibrium; therefore, one sees a convergence that forcefully binds the members of the pair. In the second kind, three colors are at play, but only

one of them is present in both mixtures, and it inverts its role. In this case, one mixture activates a tension toward the dominant that is present in the contiguous mixture, but this mixture in turn detaches itself from the relationship because of the third, subordinate color that pushes the mixture toward an equilibrium external to the pair. Therefore, one observes a strong divergence.

The experiments reported here demonstrate characteristics of various kinds of juxtapositions of color mixtures, giving us insight into the mechanisms of chromatic mimicry, the perceived similarity between colors. They suggest that chromatic mimicry does not stem only from the assimilation of one color to the color of the background due to chromatic similarity, or only from visual masking due to similarity of object texture and background texture, but also, and mostly, from the connecting and diverging tensions between colors. Conscious usage of the dynamic properties of color gives the painter and the designer a way to convey unity to polychromatic images. It allows a global vision, coordinating form with color, and preventing mimetic disintegration even under casual viewing. Thus, the same laws account for constructing figural unity as well as segregation.

1

Juxtaposing a Pure Color to a Mixture That Contains That Color

THERE ARE THREE fundamental primary colors: yellow, red, and blue. Each is contained in six mixtures. Yellow is contained in three mixtures where it is combined with red and in three other mixtures where it is combined with blue. Red is contained in three mixtures where it is combined with yellow and in three other mixtures where it is combined with blue. Blue is contained in three mixtures where it is combined with yellow and in three other mixtures where it is combined with red. Thus, each of the three primary colors is present in three mixtures with one of the other two. Within each set of three mixtures, each primary is found in one of the three proportions: dominant, equal, or subordinate. Plate 1 presents each of the three primaries in juxtaposition with each of the six mixtures that bind it to the other two primaries. In plate 2 the three balanced mixtures (orange, green, and violet) are placed between the two primaries that compose them. In figure 3, finally, each of the three primaries is shown in its area of the color disk, surrounded by the six mixtures that contain it. Next to the primaries, to the right and left, are the mixtures in which each pure color is present as a dominant. Next to these are the balanced mixtures. Next to the balanced mixtures, finally, and farthest from the pure color, are the mixtures in which the primary is present as a subordinate.

EFFECT OF JUXTAPOSITION ON THE COLOR CONTINUUM

There are three ways to juxtapose two mixtures. First, a pure color can be placed next to a mixture where the dominant is still the same color while the subordinate is one of the other primaries. In this case the mixture is perceived as a deviation of a pure color toward another hue, as if a mildly divergent motion tended to detach the former from the latter. However, a tension of opposite nature is also activated, as if the mixture were attracted toward the purity of the dominant color. Thus, a double opponent tension occurs in this kind of juxtaposition. Second, a primary can be juxtaposed to a mixture where that same pure color is subordinate. In this case the situation is reversed, for the juxtaposition appears to contain two different colors, one of which is moderately under the influence of the other. Thus, it is as though a bridge connects one color with the other, bringing them closer even if the two colors remain fundamentally different. Third, a pure color can be juxtaposed to a balanced mixture, for instance blue-yellow (BY) yielding green, yellow-red (YR) yielding orange, or red-blue (RB) yielding violet. In this case, the diverging pull due the presence of a second color increases as a consequence of the equal propor-

7

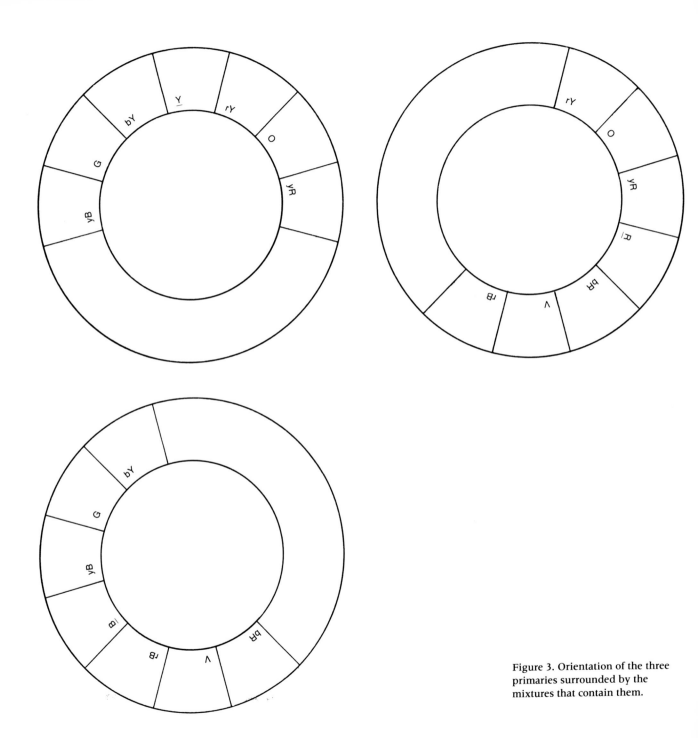

Figure 3. Orientation of the three primaries surrounded by the mixtures that contain them.

tion of that color in the mixture. There is a lack of balance in the pattern, as if the composition had a missing element—the other color contributing the mixture. Indeed, the nature of the balanced mixture is fully unfolded only when the mixture is placed between the primaries that compose it. Only then does the pattern become complete (see pl. 2).

From the last example one can begin to appreciate the importance of going beyond juxtapositions of pairs, and to consider compositions where primaries are inserted in sets of many mixtures. Juxtaposition of pairs, with their increasing levels of divergence, now become building blocks for gradual passages from one pure color to another, generating a chromatic continuum of hues that are all bound to one another by the presence of common primaries in intermediate mixtures. Occasionally, in these cases the pure color can become an apex for all the mixtures to which it is juxtaposed. Arnheim emphasized that pure colors are often employed in painting to indicate maxima of curvature, as the points of greatest convexity or concavity of a volume surface. In Cézanne, the farthest point in the space between two objects is often depicted with a pure blue. Similarly, surface areas that are closer to the viewer—think of an apple—are left white when using watercolors, or painted with a pure color when using other techniques. In all these cases, a continuum of juxtapositions is established, and its properties can be used to create connections and divergencies in a manner that will be described in the following chapters.

COLOR PAIRS AND THEIR CONTEXT

Any kind of color pair can be analyzed in abstract terms, but its material instantiation is always surrounded by a context. Consider the following situations:

1. A color pair may be isolated over an achromatic background (white, black, or gray). In this case, the pair can express its peculiar tension, or its stability, devoid of external influences.

2. A pair may be isolated over a chromatic background. In this case, to emphasize the pair most clearly one must surround it with the hue that is complementary to the pair as a whole. This solution has the advantage of providing maximum contrasts while also completing the composition chromatically.

3. A pair may be contiguous to other hues. In this case, two things can happen. If the forces in the composition support this, the pair can split, and its

members can bind to other contiguous hues so that new combinations are formed. These new groupings can even appear to be on different depth planes, as in the case of perceptual transparency. Or, if there is cohesion between the members of the pair but divergence with the contiguous hues, the pair can become a perceptual "figure" over a chromatic background. However, such pairs are placed between contrasting hues (for instance, green and blue to contrast with the pair yellow–reddish yellow; or red for the pair yellow–bluish yellow), and they always become a unitary area within the chromatic continuum. Thus, despite diverging tendencies, these pairs are best suited to take part in chromatic contexts in which the pure color becomes an apex.

CHROMATIC CONTINUUM

Let us examine now how one can insert each of the three pure colors into a chromatic continuum. Plate 3 shows once again the three pure colors, each connected to the six mixtures that contain it. The mixtures surrounding yellow are: (left, top to bottom) bluish yellow, green, and yellowish blue; (right, top to bottom) yellowish red, orange, and reddish yellow. For red, these mixtures are: (left, top to bottom) yellowish red, orange, and reddish yellow; (right, top to bottom) reddish blue, purple, and bluish red. Finally, for blue the mixtures are: (left, top to bottom) reddish blue, purple, and bluish red; (right, top to bottom) bluish yellow, green, and yellowish blue.

Because the mixtures to the right of yellow are the same as those to the left of red, and because the mixtures to the right of red are the same as those to the left of blue, the three groups are readily joined in a continuum. The junction of the three groups is illustrated in plate 4. As the configuration obviously begins and ends with the same hues, it would be natural to think of the continuum as wrapped on the convex surface of a cylinder. However, for ease of drawing it is more practical, and preferable, to build a two-dimensional model. Thus, we reduce the configuration to the section of a cone. This makes the volume more suitable to be represented on a closed disk, which displays the whole chromatic continuum in a single view (pl. 5).

PURE COLOR AS APEX IN THE CHROMATIC CONTINUUM

Two factors are responsible for making a primary color the apex of a chromatic continuum: phenomenally defined purity, and greater brightness than the mix-

tures in its group. A fundamental color is pure when it does not contain influences from the other two primaries. When a pure color is juxtaposed to a mixture that contains it, its role in the pair becomes neutral and unilateral. Directional tensions are activated only in the nearby mixtures. The asymmetry of this kind of pair is further emphasized if the fundamental color is brighter than the mixtures in its group. The notion of color brightness is due to Schopenhauer, who noted that two parts of blue are needed to match one part of orange, and three parts of purple are necessary to match one part of yellow. The juxtaposition of a pure, brighter color to a mixture of its group can represent, most coherently, the last step of a staircase that has the pure color at its top. Because yellow is the brightest of primaries, each mixture containing it necessarily will be duller. Thus, yellow as an apex can be placed among any group of mixtures that bind it to red or blue, in any proportion. It will always prevail, always occupying the end of the scale (see pl. 6). Red, on the other hand, prevails only over the mixtures that bind it to blue; it will therefore constitute the area of greatest brightness among bluish red, violet, and reddish blue (see pl. 7). Finally, blue prevails in brightness only over reddish blue and violet (see pl. 8).

Red as apex and yellow as apex in a chromatic continuum are precisely the themes of plates 9 and 10, two composition of Elena Fraternali and Silvia Iazzarelli, respectively, students at the Polytechnic School of Design in Milan.

Plates 11–14 have been proposed by Arnheim to synthesize visually the quantitative relationships between primaries in the juxtaposed mixtures of the four kinds: complete inversion, partial inversion, shared dominant, and shared subordinate. Plate 11 emphasizes both the absence of the third color and the quantitative equality between the two colors forming a juxtaposition of the kind called complete inversion. Plate 12, instead, exhibits the quantitative relationships between all three primaries, when they are used to form two mixtures that produce the juxtaposition dubbed partial inversion. Bluish red, a compound of red and blue represents the quantity needed to reach chromatic equilibrium. Plate 13 presents the different quantities of red, blue, and yellow in one of the three possible combinations of the kind called shared dominant. Red, which is two times more than yellow in the first mixture and two times more than blue in the second, prevails sharply in both mixtures. Six parts of

green would be needed to reach a chromatic completion. Finally, in plate 14 we can examine a juxtaposition of the kind called shared subordinate. In it, all three primaries are present in the same quantity. Thus, a grouping is formed that does not need a completion, since it already possesses chromatic equilibrium.

2

Complete Inversion

THREE COMBINATIONS EXHAUST the range of possible complete inversions (see pl. 15), as this is the only kind of pairing that leaves out one of the colors in the triad. Thus, only two primaries are at play in each complete-inversion pair. Each primary is dominant in one of the mixtures and subordinate in the other. As a consequence, each color is accompanied in the mixture by a bit of the other. In these pairs, a process takes place as if the two fundamental colors came toward each other, without any intervention (as I have said above) of the third color of the triad.

Consider, for instance, a juxtaposition of pure blue and pure yellow. If a small quantity of yellow is added to blue, then the usually passive blue becomes dynamic. The mixture is activated with a movement toward yellow, a tension that would reach its equilibrium at a point of stability represented in this case by green, the blue-yellow (BY), the mixture in which yellow and blue balance. Conversely, if a small quantity of blue is added to yellow, then an equivalent tension toward green is provoked in this second mixture.

Thus, when the two mixtures are juxtaposed we obtain a double tension, as if the two hues converged toward a common center.

Although both mixtures display a tension toward green, they nonetheless retain their main character. Thanks to the predominance of blue in it, the yellowish blue mixture retains its blue nature. By the same token, the bluish yellow mixture has its yellow nature preserved, even if a bluish tinge appears because some blue has been added. This has two consequences. Because of this double convergence toward a common equilibrium, the juxtaposed mixtures are bound together strongly. But because the equilibrium is never reached, the tension is never released.

USING COMPLETE INVERSIONS

Given the strong connectivity of these color pairs, complete inversions are well suited for use in painting or design, their natural role being that of preserving figural unity in patterns or in many-colored objects. However, if these objects are mobile, care should be taken to avoid having their colors come into conflict with colored areas present in some reachable context. With chromatically structured objects such as wall posters, containers, scene costumes, and uniforms, one can obtain camouflage effects if the objects are seen against the wrong chromatic context. In the worst cases, these color mismatches can break figural unity, almost dismembering the object. In painting, because complete-

inversion pairs tend to pop out from their context, the strength of their cohesion becomes a compositional problem. Its solution lies in realizing that these pairs, being formed of two colors only, are inherently incomplete: They lack the third color of the triad, which therefore has the power of completing the composition chromatically without putting the unity of the pair at risk. What needs to be done, therefore, is to insert the missing hue as background or at least as part of the background (see pl. 16). An analogous, but better articulated result may be obtained by placing in the background the complementary of each color in the complete-inversion mixtures (see pl. 17) .

To better appreciate the beauty and the great unity of these kinds of chromatic completions, it is useful to consider the relative positions of these mixtures on the chromatic disk (fig. 4). Complete-inversion pairs are always very close (figure. 4a), being separated by only one hue. In this respect, complete inversions are similar to shared-dominant pairs, which are constructed with their complementary hues. In fact, shared dominants are found, at the same distances, in opposite portions of the disk (fig. 4c). We will discuss them later. At present, note that by using shared dominants as backgrounds for complete inversions, one generates contrasts between two "active" and two "passive" hues. For instance, the reddish yellow–yellowish red pair will have the yellowish blue–reddish blue pair as background. Similarly, the yellowish blue–bluish yellow pair will have yellowish red–bluish red. Finally, the reddish blue–bluish red pair will have the "yellow" pair (reddish yellow–bluish yellow).

In shared-dominant pairs, the common color plays the same role in both mixtures, that is, it is dominant in both. This identity of role for the common color conveys a quasi-homogeneity to the pair which, if used as a background, is experienced as having a single basic color. This homogeneous color, being also the complementary of the colors in the complete-inversion pair, brings out a figure thus painted with greatest clarity and unity. Interestingly, note also that by juxtaposing its complementary to each member of a complete inversion, we create a shared-subordinate pair. In this new pair, which has the same subordinate color within each member, the common color binds the two mixtures along the chromatic continuum. Shared subordinates are discussed in depth in a later chapter.

Among the color juxtapositions examined by Arnheim, complete inversions and shared subordinates are the only pairs that exhibit "harmony" as defined by Arnheim, the "neutral and objective" definition of harmony as

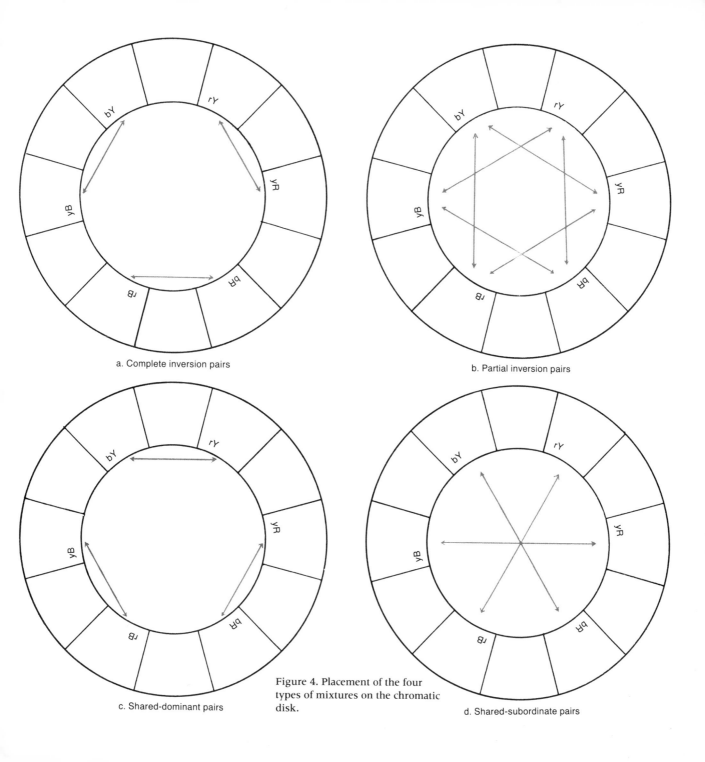

Figure 4. Placement of the four types of mixtures on the chromatic disk.

a. Complete inversion pairs

b. Partial inversion pairs

c. Shared-dominant pairs

d. Shared-subordinate pairs

connectivity within the pair. The other kinds of juxtapositions are character-ized by internal conflict, because in their chromatic components diverging ten-dencies always dominate to a greater or lesser degree. Thus, any other hue would also engender some degree of divergency when placed near these pairs, which will be readily perceived as a chromatic unity even in unplanned juxta-positions.

3

Partial Inversion

TO CREATE a partial-inversion pair, one can juxtapose mixtures in six different ways (see pl. 18). As shown by the analysis of these color pairs, all three colors of the triad are present in partial-inversion mixtures, but in different proportions. In one member of the pair, the first color is present in greater proportion than the third color, while in the other member the second color is present in lesser proportion than the same third color. However, the basic colors in the mixture are only two. In one of the two mixtures one color, say red (R), is combined with a small quantity of a second color, for instance blue (B). The combination activates a movement of red towards blue, generating a tension towards a point of equilibrium represented by violet, the red-blue (RB). In the other mixture the second color, blue, is combined with the third color so far excluded, yellow (Y). But now blue is dominant and combined with a smaller amount of yellow, and this activates another tension in the second mixture, this time in the direction of green, the blue-yellow (BY). Thus, the tension activated in the second mixture goes in a different direction than the tension activated in the first mixture. The dynamics of this relationship may be represented as follows: A tends toward B, but B in its turn tends toward C. Or A points to B, which points to C. Thus, we have a dynamic situation where one force tends to unite the members of the pair (A moving toward B), while another force prevents the conjunction (B escaping from A to go toward C).

However, the dynamics of this conflict are not sufficient to account for all the characteristics of these pairs. Partial inversions would not have such a strong diverging power unless other forces were also in conflict in these mixtures. One of these forces is distance on the color disk. This distance is always large (three steps). Moreover, in four cases out of six, the members of a partial-inversion pair are found on opposite sides of the disk (see fig. 4b). One of the members is in the area of yellow and red (active hues) while the other is in the area of green and blue (passive hues). This generates an additional kind of contrast. "Active" hues tend, with varying degree of strength, to come forward toward the viewer; "passive" hues appear to withdraw into themselves, receding from the viewer. Thus, of the two members of the pair, one appears to come forth, while the other appears to recede. This creates a divergence in depth in addition to the divergence on the picture plane.

In the remaining two partial inversions, mixtures are found on the top and bottom of the disk rather than on its two sides (see, again, fig. 4b). Thus, juxtapositions now combine one of the brighter mixtures (bluish yellow [bY] and

reddish yellow [rY]) with one of the darker ones (reddish blue [rB] and bluish red [bR]). Again, the dynamics of the combination create divergence. Consider the first pair, reddish blue (rB) versus bluish yellow (bY). In this case, the blue in the first mixture becomes active, due to the presence of red, whereas the normally active yellow in the second mixture becomes passive, due to the inclusion of blue that pushes it in the direction of green, the blue-yellow (BY). Similar transformations take place in the second pair, bluish red (bR) versus reddish yellow (rY), but in an opposite fashion. Here yellow is turned on thanks to the addition of red, whereas red is subdued because of the blue component.

Of these two pairs, the latter appears as the most strongly "repelling" of all, as if its two members were completely impossible to reconcile. Most likely, this is due to the additional effect of the brightness difference. Based on the observations of Schopenhauer, we know that the brightness of orange is about two times that of blue—that is, two parts of blue are needed to match one part of orange in brightness. Therefore, the pair made with reddish yellow and bluish red must be more out of balance than the pair made with bluish yellow and reddish blue, even if the two pairs occupy opposite positions on the chromatic disk. Thus, in these pairs the situation becomes strongly dynamic, and the forces that tend to divide the pair prevail. Two possible outcomes can result: Either the whole configuration appears in tension, or the pair splits altogether. The latter outcome depends on the context. If color A, having a tension toward color B, comes in contact with a chromatic area as strong as B and capable of attracting A, then A may detach from B and bind with C. If bluish red (bR), juxtaposed to yellowish blue, is also contiguous to reddish blue (rB), then most observers will see that bluish red and reddish blue, a complete-inversion pair (bR-rB), form a visual unit; whereas yellowish blue (yB) is left out and is experienced as background.

An appropriate context for partial inversions is provided by backgrounds containing the complementaries of the two members of the pair. As an alternative, one can also surround the pair with a homogeneous background. In this case, the pair is isolated and its converging-diverging dynamics are brought into focus most effectively (see pl. 19). The best choice for this homogeneous background is the complementary hue to the sum of the two mixtures. This is so because partial inversions are unbalanced pairs. (The only chromatically balanced pairs are shared subordinates, where each member is complementary

to the other.) Consider the color components in the last example. If the proportion of subordinate to dominant in each mixture is one to two, we note that in the first mixture (bluish red [bR]) there are two parts of red to one of blue, whereas in the second (yellowish blue [yB]) we have two parts of blue to one of yellow. Summing up, we have three parts of blue, two parts of red, and only one part of yellow. To create a chromatically balanced set, we would need three parts of each of the three colors. Hence, to counterbalance the forces in the juxtaposed pair we need two parts of yellow and one part of red. When mixed, these yield reddish yellow [rY]. Thus, the complementary hue that is needed to balance the composition is reddish yellow.

When the appropriate hue is chosen for the background, the partial-inversion pair and its dynamics are justly emphasized in the composition. Because of the joint action of complementarity (contrast and completion), however, the pair is also left somewhat bound to the background, whose hue completes the composition. The relationships between pair and background, all composed of mixtures, provide a natural way of inserting partial inversions in a chromatic continuum. Here, partial inversions can have two roles: They can emphasize the tension in the pair, or they can signal a dividing point between different areas or different depth planes. The first task is accomplished most easily when the pair is presented against a homogeneous background, so that the internal tension of the pair is left free to unfold. The second is accomplished when the pair is presented on an articulated background and its members begin to interact with other, contiguous hues. As noted above, these interactions form new bindings, which can be stronger than those in the original pair. If this happens, the partial-inversion pair splits, and one or both of its members bind with one or more hues in the background.

4

Shared
Dominant

THREE COLOR COMBINATIONS yield a shared-dominant pair (see pl. 20). In each of them, all colors of the triad are found in the components of the juxtaposed mixtures. However, their quantitative relationships are very much out of balance. Consider an example. One color, say red, is present in both mixtures as a dominant. The other two colors, yellow and blue, are both subordinate. We can say that they serve to push the same basic color slightly in two opposite directions. But the juxtaposed mixtures look as if there were actually a single color. Because of the opposite pulls of the other two subordinates, this main color undergoes a diverging tension. One of the mixtures (yR), influenced by yellow, is activated by a tension towards yellow that would find its equilibrium in orange, the yellow-red (YR). Similarly, in the other mixture (bR) one finds a tension activated by the presence of blue, and this would find its equilibrium in violet, the red-blue (RB).

This first kind of tension takes place horizontally, on the picture plane. At the same time, a second kind of movement is activated in depth, the "forward-backward" direction. Being a mixture of a dominant red with a subordinate yellow, yellowish red (yR) is active and aggressive, and it appears to come forward toward the observer. On the contrary, bluish red (bR), red with a blue component present in it, seems to go backward, to withdraw into itself, receding from the viewer. Similarly, in the pair where the shared dominant is yellow the active mixture is reddish yellow (rY), whereas its passive, receding counterpart is bluish yellow (bY). In the case of the pair where the shared dominant is blue, however, this movement in depth does not seem to occur. The photoreceptors in the human eye sense as active both the presence of red and the presence of yellow in the mixtures (rB, yB). Thus, we have a situation where both mixtures appear active, even if yellow seems to prevail because of its greater brightness. Even if there is no divergence in depth, however, the horizontal divergence still remains apparent. In this case, as in all others, context dictates whether the pair remains united due to the supremacy of the shared dominant that acts as a unifying factor, or whether the pair divides and thus marks a point of division between areas in the composition. As before, this would happen if the members of the pair came in contact with hues capable of forming a juxtaposition of stronger cohesive force. Such a juxtaposition occurs when the member and the new hue form a complete-inversion pair, the only combination capable of prevailing over shared dominants.

To segregate the pair perceptually and unify it despite its diverging tension, it is necessary to place it against one of the following kinds of background:

1. The background may be articulated with two hues, each complementary to one member of the pair (see pl. 21). In this case, the background hues form a complete-inversion pair. Because in complete inversions the two hues are strongly connected, as we have seen before, their cohesion can also cooperate with the unifying factor within the shared-dominant pair, emphasizing its figural unity. These three complementary pairs are: yellowish blue (yB) with bluish yellow (bY) for the "red" pair; reddish yellow (rY) juxtaposed to yellowish red (yR) for the "blue" pair; and reddish blue (rB) with bluish red (bR) for the "yellow" pair.

2. The background may be homogeneous, that is, made of a single hue. In this case also, the background best suited for emphasizing the shared-dominant pair is the hue complementary to the sum of the mixtures in the pair (see pl. 22). Because this hue is the most different from the pair, it also makes it most evident by means of contrast. However, this kind of background also retains a binding to the shared-dominant pair, thanks to the complementarity of its hue. These complementary hues, for each pair, are the three balanced mixtures: green (BY) for the "red" pair; violet (RB) for the "yellow" pair; and orange (YR) for the "blue" pair.

5

Shared
Subordinate

FOR THIS KIND of color pair, also, there are three possible combinations (see pl. 23). Two pure colors are activated by inserting the third color in the role of subordinate. The resulting mixture displays a tension due to the motion of the two basic colors toward the added third.

If the two colors are blue and red, then the shared subordinate is yellow, which becomes the middle point of an open sector on the circumference of the chromatic disk. The symmetric endpoints of this sector are blue to the left, and red to the right; they converge in the direction of yellow, due to the insertion of the shared subordinate (fig. 5a). This convergence is indirect. The two mixtures would find their equilibrium points in two balanced mixtures: green (BY), for blue and yellow, and orange (YR), for red and yellow. These balanced mixtures lie halfway between each color and yellow, in symmetric positions above the equator of the chromatic disk. However, the insertion of the subordinate yellow is quantitatively insufficient to reach the equilibrium points represented by green and orange. Thus, the motions of red and blue are halted at two nearest equilibria, represented by the endpoints of the equator of the disk. In those points, the two mixtures (yB, yR) are placed at the extrema of a diameter of the disk and are therefore complementary. Similarly, in the other two shared-subordinate pairs reddish yellow (rY) is united to reddish blue (rB) by an oblique diameter running bottom left to top right (fig. 5b); bluish yellow (bY) and bluish red (bR) are united by a diameter running top left to bottom right (fig. 5c).

As mentioned in an earlier chapter, the complementarity of shared-dominant pairs must be distinguished from the complementarity that relates a primary to a secondary color, for instance red (R) to green (BY). In the latter case there is full contrast, for no part of the primary color is present in the secondary mixture, the chromatic completion engendered by juxtaposing them being the only relationship between the hues. The asymmetry existing between a primary and a secondary is also worth noting. The first is a pure color, the second is a balanced mixture. In complementary, shared-subordinate pairs, however, the members of the pair are both tertiary mixtures having a subordinate color in common. The shared subordinate produces an important result: The two members of the pair, despite being at opposite sides of the chromatic disk, act in a parallel fashion as concerns their tension in depth. Their tension is active for the members of the reddish yellow–reddish blue (rY–rB) pair and for the yellowish red–yellowish blue (yR-yB) pair, and passive for the members of the bluish yellow–bluish red (bY-bR) pair.

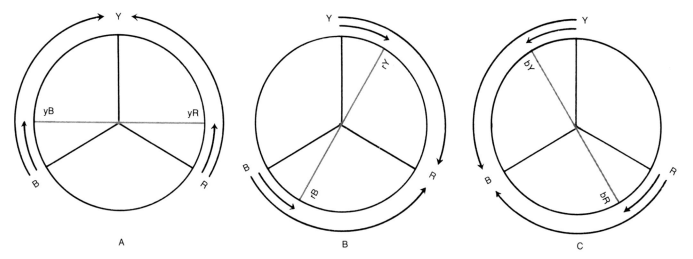

Figure 5. Shared-subordinate pairs.

Because their members are complementary, shared-subordinate pairs act as bridges between pairs that have the function of "figure" and pairs that act as "background" to complete the composition chromatically. This happens when a complete-inversion pair is placed as figure against a background made of a complementary, shared-dominant pair; or when the shared-dominant pair is placed in front of a complete inversion. Each member of the "figure" pair both connects to and contrasts with the corresponding member of the "background" pair, always forming a shared-subordinate pair. Thus, shared-subordinate pairs unite maximal diversity among members of the color pairs with a triple binding between them: chromatic complementarity, presence of the same subordinate color in the juxtaposed mixtures, and tension in the same direction of the juxtaposed mixtures.

Of course, chromatic completion may not be the only aim of a color composition. While incomplete color pairs (such as complete inversions, partial inversions, and shared dominants) can always be completed, shared-subordinate pairs cannot be completed, because they are already complete. If one wishes to incorporate them in a chromatic context but still keep them isolated, the end result will be unbalanced.

If the background is colored and is part of a chromatic continuum, shared-subordinate pairs are unified by using as background a mixture where the subordinate color in the pair is dominant (see pl. 24). In this way, a hue contrast

takes place. To isolate the yellowish red–yellowish blue (yR-yB) pair, one needs a background made of a mixture containing a dominant yellow. A dominant blue, in the two mixtures that form a shared-dominant pair containing it (reddish blue–yellowish blue [rB-yB]), will isolate a bluish red–bluish yellow (bR-bY) pair. A dominant red in the background mixtures will isolate the reddish yellow–reddish blue (rY-rB) pair. The resulting chromatic sums for these three compositions will be: gray plus yellow, gray plus red, and gray plus blue.

In all the compositions just described there is chromatic completion. While the global chromatic results remain the same, however, different outcomes can be obtained depending on the color pairs formed with the background colors. These pairs are formed in depth between the one member of the shared-subordinate pair and one member of the background pair. When these new pairs are of the partial-inversion kind, as in the examples of plate 19, the pair in the figure is articulated in a unitary fashion over a background made of reddish and bluish yellow. However, when a member of the figure pair and its corresponding member of the background pair form a complete inversion, then their relationship also has an effect on the picture plane, for complete inversions unite differently than shared subordinates, but with equal strength.

Obviously, a composition may be left intentionally unbalanced. Chromatically complete shared-subordinate pairs can be placed against colored backgrounds precisely to provoke and control a chromatic tension. If, however, the goal of the composition is to emphasize the chromatic completion of shared subordinates, then it will be necessary to present them against an achromatic background: white, gray, or black.

6

Figural Unity
and Chromatic
Unity

WE ALL AGREE that color combinations cannot be judged right or wrong. People like "harmonic" combinations, namely, colors that bind to one another; but they also like harsh combinations, such as those characterized by repelling tensions between the juxtaposed colors. Clearly, we cannot question personal taste or group preferences, which change over time and space.

Color combinations, instead, should be used for their intrinsic properties, which for the most part have to do with visibility. This is not to say that expression and the psychological dimensions of color are not important. But one has to realize that, if colors and their combinations are not perceived first, color expression will never be obtained. Only the color that activates a perceptual system becomes psychologically present; thus, only that color can become expressive. As Gestalt psychologists have taught, outside objects become psychologically present when corresponding stimuli are such that the areas of interest take on the quality of "figure." Rubin (1927) showed that an area of the visual field becomes figure because of form-grouping factors such as "relative size," "inclusion," and "convexity of margins." One must keep in mind, however, that in everyday vision perceptual contexts are not limited to form changes. Thus, the factors just named do not exhaust the list of the determinants of visual experience. The small, convex, included form of the moon is readily grouped as figure against a dark sky, but everyday vision is seldom so simple. Most objects are many-colored, and so are people, their clothing, and so on. Wertheimer (see Ellis 1939, pp. 71–88) needed simplified conditions to develop his systematic analysis of grouping by form and to discover what he called "laws of phenomenal unit formation" or "laws of visual field segmentation." However, in everyday vision those simplified conditions almost never hold. In everyday vision there is no competition between lines, which are human abstractions nonexistent in nature. There is, instead, competition between areas of different size or saturation, opaque and transparent surfaces, and lights, shadows, and highlights. Further, everything changes over time, because of movement and because of changes in the illumination. "Real" properties of physical objects are sometimes misperceived, and what is perceived may not correspond to a physical property.

Let us consider the plumage of aquatic birds. Birds that live in the protective visual flow of the sea are often invisible when they fly over it, because their colors—for instance the yellow or orange of the beak—are surrounded by achromatic backgrounds, by white, gray, or black. Also snakes often bear a

regular white-gray structure on their bodies. The structure serves as a background for the various colors on the skin, and breaks their visual figural unity. In parrots, mimicry can occur when a bird is seen against a tree. The bird becomes difficult to detect, because its bill and talons have a spotted gray color very similar to the bark on many trees. The colors of the plumage are multifarious, but never isolated on achromatic backgrounds. In these birds, the colors of the plumage are always juxtaposed, in ways that reflect the visual ecology of their environment. On certain trees of Venezuela, typical for their grapelike, reddish yellow flowers, dwell parakeets having reddish yellow plumage. The very same parakeets, however, have turquoise undersides, the same turquoise of the sky above the trees. Reddish yellow and turquoise form a partial-inversion pair, and we know that partial-inversion pairs are permeated with the strongest diverging forces. Thus, the two colors diverge, one blending into the flowers, the other vanishing against the sky—and the bird disappears from view.

In the plumage of many other kinds of larger parrots, such as *Ara ararauna* or *A. macao,* red and green predominate, arranged in large, juxtaposed areas. Because the two colors are complementary, one would say that this is a unitary combination. Thus, one would predict that the bird should be eminently detectable due to the unifying action of complementarity. However, large parrots dwell in all-green rainforests, with red flowers growing next to the leaves, and red filaments hanging down from the flowers. Therefore, the green on the birds blends with the green of the forest; and the red patterns, if they are discerned, look just like the flowers.

Unintentionally, humans may reproduce natural mimicry in the places where they display their products. For instance, very few people realize how tiresome it can be to "see" single objects accumulated on the shelves of a department store. There each color, each example of lettering cries out for attention. Color combinations on single objects attempt to unify, but elements of each combination are attracted by other colors on nearby objects. New visual groupings may be formed, and they may be different from the physical entities of the displayed objects. New, many-colored entities are then formed according to the laws of color harmony, independently of conscious logic and intent. In this way, many objects compete for attention. But much worse, great effort is required for human perception to unify single objects. It is this effort that is

mainly responsible for the visual fatigue often experienced in such conditions. Moreover, reiteration of visual objects may be of little help in making them more recognizable. Consider this classic example of wrong grouping due to re-iteration, which appeared on a billboard some time ago:

GRA GRA GRA TIS TIS TIS

The point of the message was to advertise that some service was being offered free of charge (*gratis*). Because of the wrong reiteration of visual elements, however, people grouped the lettering by similarity of syllables and read an unintelligible "gra gra gra / tis tis tis."

Some years ago, a television network broadcast a program documenting the various phases in the design of the box for a product sold in department stores. Triumphant on an empty table was the box, painted in various colors, with the brand name and directions for use written on it. Seated around the table, a group of specialists was evaluating the object, each from the viewpoint of his or her area of expertise. Obviously, a product to be prepared for marketing must be thoroughly studied. However, to one aware of the special problems posed by vision, it is also obvious that the object should have been observed in contexts that simulated real situations. Neon advertising signs, seen in all modern cities, offer extreme examples of the dichotomy between appearance and real form.

The problem of visibility in many-colored objects was negligible for those artists who wanted to reproduce "real" images—that is, to render on canvas the colors that can be observed in a natural scene. The impressionists, for instance, wanted to convey the impression of the visible colors and light in a scene. They did not need a theory of color harmony, for they could determine the appropriate juxtapositions of hues simply by observation. In a landscape, moreover, the specific tension of saturated color is not the sole determinant of the visibility of objects laid out at different distances, such as houses, trees, fields, mountains, or sky. The air between far and near objects, attenuating color contrast as a function of distance, generates a visual effect called aerial

perspective. Aerial perspective, properly reproduced on the canvas, takes care of placing the foreground tree on a nearer depth plane than the fields and the background mountains.

Let us consider, among the artists of the past, those that were most obviously "composers" of images. Thirteenth- and fourteenth-century artists, for instance, were skilled at extracting images from nature to rearrange them in a pictorial composition. To solve the problem of visibility for each figure in their work, they invented one of the most important devices of the history of painting, the colored background. The golden background of the duecento, the solid-blue sky of Giotto, but also the red and blue background of Matisse, all served essentially for the same purpose: to isolate the areas that are to become figure while preserving the unity of the whole. Modern painters have rediscovered the colored background and have adopted complementary colors for it. In this way, figures are bound even more strongly to the background and to one another. However, global unity is not the only reason to use colored backgrounds. This artistic device also allows the painter to set a "color context" for the whole composition, very much in the same way that the choice of a key sets a context and a mood for a musical piece. After the choice of the dominant color context, the other colors are free to play their role in relation to it.

Beginning in the fifteenth century, Masaccio and his followers developed chiaroscuro as a device for isolating figures from backgrounds that are no longer solid colors but have become dense textures of colored elements. Objects—figures—are distinguished from the heterogeneous background by rendering their volumes according to the subtle interplay of shadowing and highlights. The extreme solution was reached by Caravaggio: partial elements emerge from a dark background, which almost takes on the function of the previous colored backgrounds. Here a hand comes out of the dark, there the illuminated half of a face, incomplete elements that act as cues to the shapes that only amodal completion—the seeing of complete objects despite their being partly hidden from view—and past experience will reconstruct.

After this rapid overview of the pictorial devices developed in the past, we can now understand why color theory has yet to develop sophisticated concepts and instruments. In the past, colored backgrounds, aerial perspective, and chiaroscuro were the instruments generally used by artists to convey structure to their work. Only recently have artists (I should say, some artists) felt a

need to compose with color only. Those artists felt, and feel, the urge to experiment with color and understand its structure.

DESIGN

Visual designers must create visual messages for the communication of practical matters. However, their tools are tools of the arts, and these tools were built for pure expression, not for practical communication. Thus, designers suffer from the same lack of theorizing that worries the users of color as a device for constructing form. Available to designers are the seven kinds of contrast catalogued by Itten (1965): complementarity, simultaneous contrast, quality contrast, and so on. These remain valuable tools, even if at present their knowledge and use are far from widespread. But they are also insufficient. Recall that designers cannot use aerial perspective, or chiaroscuro. Only saturated colors are the tools of designers. With colors, and only with colors, designers must make objects identifiable and turn them into carriers of multiple messages. By means of color alone, designers must give character to products and enrich their form.

One condition must be met before these results are achieved. It is necessary that the use of color be appropriate to the desired distinctions between objects. Only if the choice of colors is appropriate will the reality of the objects immersed in their environment correspond to how they are perceived. Inappropriate choices can engender either partial or complete camouflage, or they can produce unpredictable groupings of colors and perceptual objects that have no counterpart in the physical world. Thus, only by understanding those forces that Arnheim dubbed "color harmonies" can we achieve an orderly correspondence between reality and its perception. These forces are the tensions that spring up between colors. To control them, it is necessary to appreciate in detail the internal structure of color juxtapositions. After my experiments demonstrated a diverging tension (that is, a discord) between tertiaries in partial-inversion pairs, I tried to develop a hypothesis to account for the structure of this kind of juxtaposition. As we have seen, two contiguous mixtures can display different behaviors in terms of depth placement ("forward" or "backward"). According to some theorists (Brücke 1866), their perceived position in the third dimension has a physical basis in the different refractive indexes of different wavelengths, which in turn correlates with the perception of color.

In the juxtaposition of bluish red and reddish yellow, for instance, red is forced to recede because of the addition of blue, while the addition of red to yellow, an already dynamic and aggressive hue, increases the energy that pulls yellow forward. Suppose one painted an object with these two colors, for instance, a sofa having one half painted bluish red and one half painted reddish yellow, on a reddish blue floor. This would generate a tendency of bluish red to bind with the background, forming a complete inversion. As a consequence, only the active half of the object would be perceived as advancing closer to the observer.

It is also necessary to keep in mind that light changes with the time of the day, according to its particular kind. Sunlight, for instance, becomes progressively bluer towards the evening. Light from incandescent light bulbs, on the other hand, remains shifted toward yellow and red. Returning to our hypothetical sofa, the transition from daylight to darkness will enhance the effect of blue in the mixtures, because of the greater amount of blue light. As a consequence, reddish yellow will still show a moderate tendency to advance, but bluish red and reddish blue will become even more detached from it. The transition from natural to artificial light, instead, will enhance reddish yellow, because of the greater amount of red and yellow in the illumination. Thus, reddish yellow will become more active. At the same time, however, the yellow illumination will combine with bluish red, causing it to appear duller. Recall that in an additive mixture yellow is complementary to reddish blue. Thus, mixing them produces gray.

In short, different illumination conditions are commonplace in our living situations. They are caused by the natural cycles of day and night and of the seasons, as well as by the changes of the weather and still other factors. Changes in the illumination enhance the negative effects of diverging factors in all discordant juxtapositions, including shared-dominant pairs, in which illumination changes attenuate the chromatic unity due to the shared color, while at the same time enhancing the divergence in depth of the members of the pair. Thus, for example, bluish red recedes even more in depth and yellowish red comes forward even more.

Still another factor that can influence color perception, if present, is difference in saturation. Greater saturation of the mixed colors produces stronger tensions, but it also causes interference due to brightness differences between the strongly saturated colors. However, pairs of maximally saturated tertiaries

do not necessarily display a brightness difference. For instance, in the pairings of reddish yellow with bluish yellow (a shared-dominant pair) and of reddish blue with bluish red (a complete inversion), the two contiguous hues have equal brightnesses even at maximal saturation. Similarly, the pairing of yellowish red with yellowish blue (a shared-subordinate pair) also has members of equal brightness. It is worth noting that the members of these three pairs are placed at the same height on the chromatic disk, if the disk is oriented correctly with yellow on top and violet on the bottom. Passive hues will then be found on the left side of the disk, while their active counterparts will be on the right side.

In a white illumination, brightness similarities promote unity between the members of a pair, whereas brightness differences tend to divide them. Thus, some color pairs do not display equal amounts of energy when maximally saturated. Within complete inversions, for instance, there is an equal amount of brightness in the pair reddish blue–bluish red, and a small brightness difference (two steps) in the other two pairs, bluish yellow–yellowish blue and reddish yellow–yellowish red. The same two-step difference is also present in two shared-dominant pairs (yellowish red–bluish red and yellowish blue–reddish blue). Between the juxtaposed mixtures in this case there is only either the pure color that is dominant in the combination, or a secondary one (orange [YR] between rY and yR, green [BY] between bY and yB). However, maximal brightness differences (four steps) are found in the two pairs reddish yellow–reddish blue and bluish yellow–bluish red (shared-subordinate pairs), and in the two partial-inversion pairs bluish red–reddish yellow and reddish blue–bluish yellow.

We can note that the two last sets of pairs, when maximally saturated, display their specific tensions with greatest intensity. This produces less cohesion in the members of shared-subordinate pairs (except for the yellowish red–yellowish blue pair, which is composed of members of equal brightness) and larger diverging tendency in the members of partial-inversion pairs.

Obviously, it is also possible to use desaturated hues after these have been brought to an equal brightness level. If the selected hue is maximally saturated at the desired brightness, then it is necessary to desaturate it by adding some gray. In this case, colors act only by means of their chromatic properties, with no interference due to differences in brightness. In short, one has to make a choice. To increase the efficacy of a color pairing, one can choose two colors

that have equal or almost equal brightness when maximally saturated. Consider plate 25, which depicts a sequence of squares divided into two parts by a diagonal line. The shapes can be organized in one of two ways. One can see a set of triangles composed by the two halves of adjacent squares and pointing alternatively upward and downward. Or one can see a set of squares, each composed by two triangles defined by a diagonal line. In both solutions, the two halves of the squares are made of two smaller triangles of different color. All the hues in the display have been brought to an equal brightness level using the pairing of yellowish blue with yellowish red as a reference. Because the edges of the triangles form a continuous zigzag line, one would expect that the first solution would be somewhat easier to see. However, in both 25*a* and 25*d* most observers tend to see preferentially the squares composed of two triangles of different color. Only in 25*b* and 25*c* do the large alternating triangles prevail.

Let us examine in detail the interactions of color in the patterns of plate 25. In 25*a,* the triangles in each square form complete-inversion pairs, whereas contiguous triangles belonging to separate squares form partial-inversion pairs. In 25*d,* the triangles in each square form shared-dominant pairs, whereas contiguous triangles form partial-inversion pairs. In 25*b,* contiguous triangles form shared-dominant pairs; in 25*c,* they form shared-subordinate pairs. Thus, in the last two patterns the favored solution (the triangles alternating along a zigzag line) also creates a harmonic pair, whereas in both these patterns the alternative solution (the squares made of triangles) creates a diverging, partial-inversion pair.

Another experiment is displayed in plates 26–29, showing colors appropriately desaturated in order to equalize them in brightness. The rectangles in plate 26, for instance, could represent color combinations in a man's outfit. Imagine a man wearing trousers and a sportcoat, the color of the trousers forming a partial-inversion pair with the color of the jacket. If one saw the trousers-jacket combination against a white background, it would appear dynamic but unitary. Its dynamic character stems from the diverging tension of partial inversions, whereas its unitary character stems from the isolation provided by the white surround. If the combination were displayed in the window of a store, against an achromatic or complementary background, it would be just fine: the tension would demand attention, and the discordant character might even be attractive. But suppose the combination was actually worn by

someone walking in the street. As other people in other clothes passed by, the colors in the combination would come in contact with other colors. Whatever these colors might be, the members of the partial-inversion pair would split and bind with them, for partial inversions are the most diverging pairs of all. The visual effect would be a loss of figural unity, with each of the colors worn by the person binding with colors worn by other people. The example in plate 26 is meant precisely to demonstrate what happens when two such combinations come in contact with each other. As one might have anticipated, they form a complete-inversion pair: the upper left (yR) binds with the upper right (rY); and the lower left (rB) binds with the lower right (bR). The resulting arrangement is somewhat disturbing. Figural unity would dictate that we group figures along the vertical, but the color combinations favor the horizontal arrangement. Unconsciously, we register the conflict. Plate 27 represents the same colors, this time arranged correctly to avoid conflict between figural and chromatic unity.

Finally, in plate 28 two hypothetical men, wearing colors that form partial-inversion pairs, when placed side by side give rise to two horizontal, shared-dominant pairs. Thus, even this kind of mixture prevails over the figural factor, despite its diverging component. In plate 29, again, the same colors are arranged so as to form shared-dominant pairs along the vertical, thus avoiding conflict between figural and chromatic unity. For the sake of clarity, the examples presented here exploited combinations yielding the most extreme effects. Obviously, it would be possible to investigate all possible combinations by systematically pitting each kind of color pairing against all others. Perhaps the examples in this chapter will stimulate some of my readers to experiment with these combinations, and to see for themselves.

7

Applications in Painting

THE THEME OF VISIBILITY is clearly important, and the intuition of Arnheim, dating back to his book, *Art and Visual Perception: A Psychology of the Creative Eye,* published in 1954, should have deserved much ampler experimentation by now. The discoveries and the rules of figural unity, however, are hardly the only aspect worth considering. Let me describe for you a color reproduction of a landscape by Cézanne. The work is based on concords of blue-green and yellow-green for the rendering of the trees, whereas brown and reddish yellow are used for the terrain beneath the trees. There is a lake, very bright and wide on the left but narrower at the center and on top, where it takes on a turquoise color (yellowish blue). This color becomes saturated when it comes into contact with the brightest color in the composition, the yellowish red of the roof in one of the two houses in view. The two complementary tertiaries, which form a shared-subordinate pairing, are the chromatic center of the work. The dynamic contrast due to complementarity is used here as a visual center, a locus of maximum color intensity. The other house, placed on the bottom left, has the roof painted in the same yellowish red as the first one, but much duller. This serves as a reminder of the main focus of the work, while at the same time defining one of the inferior vertexes of a triangle having the apex at the yellowish blue–yellowish red concord already described.

This use of contrast between complementary colors is reminiscent of the use of intervals in music. In a paper published in *Leonardo,* musicologist Alan Wells (1980) examined the relationship of the chromatic circle of twelve colors to the musical circle of fifths. He found impressive similarities between the two models of harmonic modulation. For instance, contrasting complementary colors are found on opposite sides of the chromatic disk, just as contrasting notes are opposite on the circle of fifths. It is very striking that these diametrically opposed notes form intervals that medieval theorists already recognized as devilish dissonances that need to be handled with great care.

In many other works Cézanne used the method of gradually increasing color saturations until a maximally saturated concord is created by a pairing of complementary tertiaries. Examples are the *Woman with Coffee-Pot,* as well as the portrait of his wife on a red chair (pl. 30). As a variant, in another portrait (of a young man with white shirt and red waistcoat) he substituted the pair of tertiary complementaries with the reddish blue–yellowish red air, a partial inversion. This pairing produces a strong feeling of clashing, thus becoming the center of maximum color intensity. Placed on the bottom left of the painting,

this pair becomes its very center of gravity (pl. 31). It will be useful to return to the analysis of this work later on.

Turning again to the use of complementary pairs, it is interesting to note that Cézanne had a real predilection for the pairings of tertiary mixtures. One must not forget the dynamics of complementary pairs, which consists in the two partners continuously reinforcing each other. This dynamics, which made Goethe say that complementary colors continuously seek one another, is due to two factors. The first, which I have already described, is the need of chromatic completion. The second is the phenomenon called successive contrast. When a person fixates one color intensely for some time, the photoreceptors in the retina are saturated, resulting in a production of complementary pigments. If the person then fixates elsewhere, these pigments are projected onto the other colors in view and mix with them. For instance, if one fixates red, the physiology of the retina produces green, which is added to any green already present, reinforcing it. Fixating the reinforced green in turn causes the red to be reinforced, and so on in a dynamic crescendo. Incidentally, it seems likely that this mechanism of successive contrast also has a protective function. Just as a prolonged sound after a while ceases to have an effect on the organism and is no longer heard, prolonged exposure to the same color causes in the organism a defense reaction that turns it off by means of successive contrast. For instance, if one looks at a red after having inspected another red, the second red looks duller, because the green, produced in the eye by the prolonged observation, gets mixed with the second red and turns it off.

Based on these observations, we can derive the rule that complementaries should always be inserted in compositions, even if small quantities, to avoid colors losing their intensity. To achieve chromatic equilibrium, we can use ratios between different degrees of luminance, which were already described by the young Schopenhauer. To bring a composition out of balance, that is, to produce guided tensions that are a fundamental expressive device, we can alter these ratios by multiplying active or passive colors by the appropriate factors. Suppose that to balance one unit of yellow requires three units of violet. If we wish to increase the strength of the yellow, instead of eliminating the violet we can insert more units of yellow per unit of violet (six or even ten). In this way, even if it is present in a small quantity, the violet will keep reinforcing the yellow, thanks to the mechanism just described.

The effect of clashing is even more violent than the effect produced by a

pair of complementaries, for complementary colors, despite the contrast, form a harmonic pair. The harmony stems from two factors: first, that complementaries complete each other; and second, that complementary tertiaries share one color that is present in both in the same quantity.

In the clashing partial-inversion pairs, on the contrary, everything is in tension and out of balance. Unless we try to counteract this diverging tension, the composition may lose its chromatic unity. The visual result is disruptive for the visibility of the represented object, which becomes difficult to detect or altogether invisible. However, this will also be the best possible result in the given situation. If the pair is isolated, it will display a tension that has nothing of the feeling of completeness found in complementary pairs. This situation is found in the works of Cézanne, where the partial-inversion pair is often surrounded by an achromatic background.

8

Examples of Chromatic Juxtapositions in Pictorial Works by Cézanne, Picasso, and Matisse

LET US CONSIDER how some great masters (Cézanne, Matisse, Picasso) used juxtapositions of unbalanced, tertiary mixtures to define a chromatic theme for their works. Cézanne's repeated use of pairings involving tertiary hues (shared subordinates or partial inversions), for instance, indicates that these themes are not accidental features of his compositions. Rather, they are conscious experiments on the function of what we could call the "tensional center of gravity"—the part of a painting bearing the color that becomes the center of the composition due to its contrasts and tensions.

EXAMPLE 1: Cézanne, *Madame Cézanne in a Red Armchair* (PL. 30)

The chromatic theme of this composition is developed by a relationship between yellowish red and yellowish blue, which is best focused in the upper part of the figure and the chair. There is the center of the work. The contrast between tertiary complementaries reappears on the bottom left, between the arm of the chair and the stripe of intense turquoise (yellowish blue) that belongs to the background. A second theme of the composition is found in the relation between bright and dark of the face and hair of the figure.

Observe the yellowish red of the chair. It is an aggressive color that would normally tend to come forward more than the figure. To make apparent that it belongs to the background, not to the figure, this mixture is bound chromatically with the reddish yellow on the back wall, forming a complete-inversion pair. The complementarity comes back in the counterpoint of geometric patterns, painted in reddish blue and displayed against the reddish yellow background. The two mixtures form a concord of tertiary complementaries, a shared-subordinate pair. The shadow on the face is painted in yellowish blue, thus reiterating the dynamic theme of complementarity set forth with the yellowish red chair and the yellowish blue dress.

Another important element of the painting, in part because of its position at the top of the composition, is the face. Enhanced by the contrast with the dark hair, the brightness of the face completes the convex form of the figure's arms, just as the bright hands, placed on top of a lighter green-blue, complete the convex form of the skirt.

EXAMPLE 2: Cézanne, *Young Man in a Red Waistcoat* (PL. 31)

The chromatic center of this painting is at the bottom left. In that location, two contrasting forms intersect, almost as if the painting were animated by two

motions along crossing trajectories. The clearest is outlined by the left arm of the figure, which descends by its connection with the right shoulder, tracing a curve from top left to bottom right. This movement begins, but in a more subdued manner, from the drapery at the top and proceeds along two paths, one following the trajectory of the arm, the other following the curve of the upper body. Reduced in size by the strong foreshortening of the perspective view, the left arm reiterates the theme on a smaller scale.

There, where the color of the clothing meets the color of the white-sleeved arm, is the center of the painting both formally and chromatically. In that location, color finds its maximum saturation and provokes the strongest tensions, due to the pairing of reddish blue and yellowish red, a partial-inversion pair. Each of the two contrasting hues also binds, on top and at the bottom, with another mixture. On top, a harmonic, complete-inversion pair is formed by reddish yellow and yellowish red. At the bottom, a shared-subordinate pair is formed by reddish blue and reddish yellow. Thus, the point where the contrast is most dramatic is the pairing of reddish blue and yellowish red. Because the two colors are maximally saturated, the effect of clashing is stronger. Two reddish yellow areas are placed at the top and bottom of the contrasting pair. Because of their similarity and their position surrounding the pair, these areas are unified perceptually and become a background for the contrasting pair. On the left, the contrast between yellowish red and reddish blue is enhanced by the white of the sleeve. This adds achromatic contrast between dark and light to the already strong color contrast between the members of the pair, making them even more conspicuous. Finally, on the far left the two main mixtures are surrounded by a dark blue-green area, which has the function of further enhancing the reddish yellow color of the waistcoat. This happens because of the lightness difference and also because the colors form a partial-inversion pair. The use of the tension engendered by a yellowish red–reddish blue pairing is apparent also in another of Cézanne's compositions, the *Woman with Coffee-Pot* (painted around 1890), now in the Louvre, Paris.

EXAMPLE 3: Matisse, *The Dance* (PL. 32)

This composition is carried out by means of only three hues, all tertiary mixtures, arranged in three main pairings. The first is formed between the two colors in the background, reddish blue above and yellowish blue below (shared dominant). The second and third are formed by pairing the color of the nude

figures, yellowish red, with the reddish blue (partial inversion) and the yellowish blue (shared subordinate) of the background. The latter is a pair of complementary tertiaries.

Thus, the excitement of the upper part, due to the vigorous movement of the bodies, is matched in the painting by a strong effect of clashing of colors. In the lower part, where the colors form a shared-subordinate pair, the movement is slower, the agitation calms down. The central figure on the bottom is almost dragged along, while at the same time color contrast is lessened by the complementarity of tertiaries. In the same year, and using the same colors, Matisse also painted *La Musique*.

EXAMPLE 4: Picasso, *The Muse* (PL. 33)

In this composition, the background is divided into four communicating areas, forming two complete-inversion pairs. In the upper part, the background is a wall, rendered by means of yellowish blue and bluish yellow areas. In the lower part is a floor, upon which rest two figures and a mirror, bound by a complete-inversion pairing of reddish blue and bluish red. This is the same kind of pairing that binds the two colors on the wall. The mirror, on the left, is bluish yellow, and with the floor, which at that point is bluish red, it forms a shared-subordinate pair. Thus, thanks to lightness contrast the figures and the book are nicely distinguished from the background constituted by the two complete-inversion pairs. At the same time, their unity is preserved thanks to the complementarity of yellow and violet, which is also reinforced by the yellows on the mirror on the left and by the yellows on the face of the young woman on the right.

ANALYSIS OF *RED FIELD* (PL. 34)

Plate 34 is a reproduction of one of my paintings. In this composition, I have applied the principles of color harmony discussed in this book, as well as the principles of perceptual transparency. As we will see later on, the phenomenon of transparency occurs when one sees two things, superposed on different depth planes, in the same position of the visual field. This creates an additional kind of contrast between surfaces of different kinds, opaque and transparent, so that the latter appear almost filmlike. But in this as in many other works of mine, transparency is used to increase the dynamics of the pattern. By this I mean that some of the structures in the composition become ambiguous, form-

ing sets that can reverse their relative depth during observation. Independently of will, the observer ends up seeing that the visual units of the composition continuously exchange their role. What was seen as figure suddenly becomes background, and vice versa, at an ever-increasing rhythm.

In the composition analyzed here, there are three dominant forms. However, due to various kinds of visual ambiguity at play, these forms are disrupted during the observation, and other forms emerge. All three main forms resemble an elongated ring, but two of them are placed vertically, whereas the third lies horizontally in the lower part of the painting. The three rings are interrupted horizontally by two narrow illusory figures. In illusory figures, a phenomenon investigated especially by Gaetano Kanizsa (1955), the color of the background is perceived as if it belonged to an opaque occluding surface. Even though this surface has no "real" margins to stimulate the retina of the observer, these margins are nonetheless seen as bounding the figure.

The rings are also interrupted, along the horizontal axis, by two transparent layers shaped as narrow vertical stripes touching the upper and lower edges of the painting. The left rectangle is yellow, and the right one is blue. Both are instances of complete transparency, as it is customary to call transparency displays where the colors of the transparent layers are not seen directly, but as part of a mixture with the colors of the underlying background. However, these stripes have been deliberately painted as if they were transparent in some parts, but opaque in others. Where the stripes appear transparent, the continuation of the larger ring is visible under the transparent layer. In this case, the margins of the ring take an alternative direction, revealing a smaller shape that is formed partly by the opaque ring on the background and partly by its continuation seen through the transparent layer. The remaining part of the opaque ring appears occluded by the stripe, which in that part is itself opaque, so that part of the ring seems to complete amodally (that is, nonvisually) behind the stripe.

Obviously this alternation of transparency and opacity is purely perceptual. It would be impossible for a physical surface to be both transparent and opaque at the same time. Thus, the effect is achieved by painting in oils and using strata of opaque colors to achieve a purely visual effect of transparency. The effect could not be produced using physically transparent strata, as when painting in watercolors.

Finally, in the horizontal ring painted in the lower part of the composition,

two alternative percepts can occur. The first one is a sort of C placed on the lower right angle; the second one, a larger ring that begins on the right and continues behind the two transparent stripes.

All the colors employed in the composition are tertiary mixtures. Thus, some of them form pairings that bind different hues harmonically, while others form pairings that engender divergence because the hues are disharmonious. Further, all colors form pairs of complementaries that are not balanced quantitatively. The reddish yellow of the background is dominant, and all the other hues in the composition are seen relative to it, so that two main color pairings are formed. The first one, formed by the two blue regions on the left, is a shared-dominant pairing (reddish blue–yellowish blue). The second one, formed by the two regions on the right, is a complete-inversion pairing (bluish red–reddish blue). Both pairings bind harmonically one half of the background with its half seen through the transparent stripe. However, the color pair on the left also has a disharmonious component, for one of the blue regions also has a yellow tinge, whereas the other has a red tinge. As a consequence, a tension arises that is repeated, at a more global level, by the tension between the yellowish red of the background and the reddish blue of the figure, which together form a partial-inversion pairing. Due to this increased chromatic tension on its left part, the composition acquires greater balance.

On the other hand, the reddish yellow ring is bound harmonically with the yellowish red background, forming a complete-inversion pairing with it. Although this part of the painting is chromatically weaker, the insertion of additional effects of transparency counterbalances the greater tension of the left part. These effects are noticeable inside the transparent stripes both on the left and on the right. They confer greater dynamism to the lower part of the composition by offering a large variety of chromatic solutions.

9

Complete Transparency in the Perception of Colored Displays

PERCEPTUAL TRANSPARENCY implies that at least two surfaces are seen in the same position of the visual field but on separate depth planes. If this is the case, then the surface that is in front and that can be seen through is defined as transparent. The other surface—or surfaces if there are more than two depth planes—is perceived as opaque. This phenomenon poses a special problem in the study of perception, for it implies a perceptual scission in the area that appears transparent, where the same local stimulation yields a percept of two superposed planes, so that a single color is split into two separate colors. The problem is to find the conditions that cause this scission.

Previous investigations have shown that two sets of conditions are relevant to perceptual transparency. The first set of conditions has to do with the form of the surfaces in the display. In this regard, Arnheim (1954) has asserted that one can derive the necessary conditions for transparency from the fundamental principle of Gestalt psychology—that is, the tendency of visual forms to organize in the simplest configuration compatible with a given stimulus arrangement (see pl. 41). The second set of conditions has to do with the lightness and color of each surface in the display. Lightness and color conditions for the perception of transparency are more complicated than form conditions. Up to the present, studies of transparency have focused on the contribution of lightness. The investigation I present here is concerned with the necessary color conditions. However, before I discuss my findings it is necessary to clarify the relationship between phenomenal and physical transparency.

Any physical device that transmits light—a veil, a filter, a rotating episcotister—can be used to produce phenomenal transparency. However, it is well known that under appropriate conditions a physically transparent surface appears opaque. Tudor-Hart (1928) demonstrated that a physically transparent surface looks opaque if seen over a larger background. With demonstrations such as this, it became clear that looking only at the area shared by the transparent layer and the background could not account for the conditions yielding perceptual transparency. To understand the conditions for transparency, it was necessary also to pay attention to the context. Investigators began to realize that the perception of transparency depends on the presence of more than one adjacent surface in the visual field. Thus, the areas next to the shared area had to be considered as well.

Ultimately it was agreed that there were three areas of interest. One was the shared area, formed by the two superposed figures. The other two were

those figure parts that remained visually related. In his systematic investigations Fuchs (1923) demonstrated that the shared areas had to be split into two planes to produce the perception of transparency. This splitting did not take place if the shared area, common to the two figures, was isolated. The problem posed by the finding was precisely to account for this splitting.

Talbot's law of color fusion states that the reflectance of the color resulting from fusion can be predicted from the reflectances of the component colors. The fusion reflectance is the arithmetic average of the component reflectances. Taking Talbot's law as a starting point, Grace Moore Heider (1933) put forth the following hypothesis. The color of the area of superposition (hereafter the stimulus color), is the product of additively mixing two other colors. In the perception of transparency, a process of scission of the stimulus color takes place. The first of the colors resulting from scission is seen as belonging to the underlying opaque surface, the second, to the transparent layer. Thus, according to this hypothesis, the necessary condition for perceptual transparency is a scission of the colors that have originated the stimulus color by means of an additive synthesis.

As investigators were studying the color conditions for perceptual transparency, Fuchs (1923) continued to address the issue of the form conditions, pointing out that the two areas of a transparent surface must be unified into a figural whole. A study by Gaetano Kanizsa (1955), at the University of Trieste, demonstrated that (1) the minimum number of areas required for perceiving complete transparency is four, not three; and (2) when transparency is perceived, of these four areas two are seen as opaque and belonging to the background, the other two as transparent and belonging to the figure. Kanizsa noted that with four areas, the part of the figure that lies over the empty background also looks transparent, not just the part that lies over the opaque background figure. This initial observation of Kanizsa became the basis for the mathematical theory of transparency and specifically for the model of the lightness conditions developed by Fabio Metelli (1970, 1974) at the University of Padua. Referring to Kanizsa's findings, Metelli wrote, "This is an important observation. It represents one of the foundations of the mathematical theory of perceptual transparency, for only after this observation did it become apparent that the hues in a pattern yielding the impression of transparency are four, not three as it was previously believed." Metelli also isolated three other conditions: coincidence of margins (the margin dividing two ares of a transparent

figure must coincide with the margin that divides the two areas of the background); topology (the lighter area of the figure must lie on top of the lighter area of the background, while the darker area of the figure must lie on top of the darker area of the background); and reduction of contrast (the lightness difference between the regions of the figure must be smaller than the lightness difference between the regions of the background).

Investigating reversible figures, such as those reproduced in plate 42, Guido Petter (1958) performed a series of experiments on the lightness conditions that determine which part of the pattern becomes figure. He varied the lightness of the gray in the common area of the two superposed disks, recording whether it united with one or the other to form the transparent layer. As it turned out, the condition that determines whether the fusion area unites with one or the other of the two adjacent areas is the degree of lightness similarity. This causes the areas on the transparent layer to have a smaller difference in lightness than the area on the background. The finding is consistent with the tendency toward simplest structure: in an ambiguous pattern, an area will unite more easily with the area most similar to it in lightness (or in color).

Initially, these experiments were performed with transparent films, projecting colored lights or using episcotisters. An episcotister is a device capable of rotating at fusion speed a disk with open sectors. The width of the sectors as well as the hue of the solid sectors can be varied at will. In front of a colored background, the rotation produces a perceptual mixture of the background color with the color of the solid sectors, and one has the impression of seeing a transparent veil. However, as soon as it became apparent that physical transparency is unnecessary for perceptual transparency, Metzger (1955), and then Metelli and others, began to use the so-called mosaic method—that is, they began to generate transparency displays by juxtaposing and gluing together colored paper of different hues (pl. 43). With this method, it becomes possible to vary systematically each of the relevant areas. Plate 44, from the work of Gaetano Kanizsa, illustrates some further examples of transparency created with this method.

METELLI'S MATHEMATICAL MODEL (PL. 46)

Metelli (1974) worked out a mathematical model of perceptual transparency with achromatic colors, that is, with shades of gray. From the model, he was able to derive the necessary conditions for perceiving a gray-scale surface as

transparent. The foundations of his theory, which represents a basic result in the theory of what he called "complete and balanced transparency," are the following: (1) Talbot's law; (2) the theory of chromatic scission of G. M. Heider; and (3) Kanizsa's finding that four, not three, areas need to be considered in an account of the perception of transparency.

Consider the configuration of plate 46, reproduced from Metelli's paper published in *Scientific American* (1974). As noted earlier, Talbot's law of color fusion states that the reflectance of the fusion color can be determined if the reflectances of the two component hues are known. The reflectance of the fusion color is given by the arithmetic mean of the two reflectances. The two component reflectances contribute to the fusion color in definite proportions, which can be expressed with the following equation:

$$c = \alpha\, a + (1 - \alpha)\, b$$

where c is the fusion color, a and b are the reflectances of the two fusing colors, and α and $(1 - \alpha)$ are the proportions of the areas of the component hues contributing to the fusion color. The two component hues are present as two complementary sections, adding up to unity. Thus, the larger one section is (as represented by the factor α), the smaller the other will be. But now recall that, according to Heider, chromatic scission is the inverse of the chromatic fusion. If this is the case, then Talbot's equation can be rewritten as

$$p = \alpha\, a + (1 - \alpha)\, t$$

where p is the fusion color, and a and t are the two component colors into which the fusion color splits in the proportions α and $(1 - \alpha)$. Expressed in this way, Talbot's law becomes the quantitative law of achromatic transparency. If $(1 - \alpha)$ is the portion of the fusion color that is assigned to the transparent layer, then the smaller this portion, the larger the portion that will be assigned to the opaque background: the smaller $(1 - \alpha)$, the greater the transparency. Thus, α is a coefficient of transparency. However, another factor must taken into account. Although in Talbot's equation the measure of lightness, expressed as a reflectance, is predetermined, the inverse of Talbot's formula has an infinite number of solutions, because it is an equation with two unknowns. But as we have seen, the areas at play in a transparency display are four, forming two

superpositions; therefore, the transparent layer has two colored areas and both can be split. If we assume that the degree of transparency is uniform across the layer and balanced in the two scissions, then a second equation can be written for the other area, as follows:

$$q = \alpha' b + (1 - \alpha') t'$$

In this fashion, a system of two equations is formed. If $\alpha = \alpha'$ and $t = t'$ (if transparency is uniform and balanced in the two areas), then the system can be solved and gives the following solutions:

$$\alpha = \frac{p - q}{a - b}$$

$$t = \frac{a q - b p}{(a + q) - (b + p)}$$

From the above formulas, it is possible to derive two necessary conditions for perceptual transparency: (1) the difference in lightness between p and q must be greater than the difference between a and b; (2) if p is lighter than q then a must be lighter than b, which is the same as saying that the lighter area of the transparent surface must lie on top of the lighter area of the background, while the darker area of the transparent surface must lie on top of the corresponding darker area of the background.

All these conditions must be met for perceptual transparency to occur with achromatic hues. With chromatic hues, as we shall see shortly, these conditions are still necessary, but they are not sufficient. In any event, if the above-mentioned conditions are violated, the perception of transparency is impeded.

PERCEPTUAL TRANSPARENCY IN COLORED DISPLAYS

Although the hypothesis set forth by Heider (1933) was meant to account for achromatic as well as chromatic displays, several investigators who have employed the mosaic method have confined their interest to achromatic transparency. Thus, these researchers—Metelli among them—have looked only at gray-scale surfaces on the lightness continuum that goes from white to black. Meanwhile, Osvaldo da Pos at the University of Padua has been studying per-

ceptual transparency in colored displays. As we shall see, contrasting observations on colored-surface transparency have also been reported by the American investigator Jacob Beck.

On a gray scale, the only difference between two hues is their relative lightness. Thus, a single number suffices to describe this variable completely. If we use colors, however, three independent variables must be specified: hue, brightness, and saturation. According to a widely used method of color measurement, each color may be defined by three numbers, called tristimulus values. Tristimulus values are referred to as X, Y, and Z. They define the proportions of three standard primaries (called generators) that must be combined in a mixture to match a color perceptually.

Because achromatic hues can be defined by a single number, lightness on the gray scale, Metelli was able to model perceptual transparency with a single system of equations. In his work on transparency with colored displays, Da Pos (1976a, 1977) has worked out a mathematical model similar to Metelli's. However, because chromatic hues are defined by three parameters, Da Pos modeled transparency by means of three systems of two equations.

To test his mathematical model, Da Pos employed a set of colored papers produced by the Swedish company Color Center. This company produces a set of up to 600 different-colored papers, divided into twenty-four hues and classified according to the Hesselgreen system. In this system of color classification, just as in the Munsell system developed in the United States and in the German DIN system, colors are classified using the principle of perceptual equidistance.

Da Pos examined both complete, balanced transparency (Da Pos 1976a) and partial transparency (Da Pos 1977). Before we proceed further, however, it is necessary to define complete, balanced, and partial transparency. I have already mentioned the first two terms when discussing Metelli's model, but the third is new.

When a figure is superposed on two background colors, or on a background figure, two regions are defined in the configuration. They are the areas shared by the figure and the backgrounds behind it. Complete transparency occurs when the figure appears transparent in both. Balanced transparency occurs when both regions appear equally transparent. If both conditions apply, the approach of Metelli can be used to account for perceptual transparency seen in both regions. In some other situations, however, only the region of su-

perposition is seen as transparent, while the other region is perceptually opaque. In this case, we speak of partial transparency. Partial transparency occurs, for instance, with two partly overlapping rectangles, one black and one white, over a gray background (see pl. 45). The area where the two rectangles overlap, according to Metelli's model and to Talbot's law, must take on a lightness in between the lightnesses of *A* and *B*. Note that the spatial ordering of the rectangles is reversible, in the sense that either the black or the white rectangle can be seen in front of the other. But, whatever the perceived depth order, the region contiguous to the area where the two rectangles overlap remains perceptually opaque. This has to be so, because this region is either all black or all white, and therefore it cannot be the result of fusion with the background color. If the color of this region resulted from fusing two colors in the proportions α and $(1 - \alpha)$, it should take on some shade of gray. Instead, all the color is assigned to the layer on top, which becomes opaque. As a consequence, the perceptual scission takes place only in the area where the two rectangles overlap. In short, partial transparency occurs when form conditions for transparency are fully met, but lightness conditions are respected only in the region of superposition, thus producing a contradictory situation.

Here is how Da Pos himself described his method and the results of his investigations of complete and balanced transparency:

> The colors of the background surfaces *A* and *B*, taken from the Hesselgreen set, were set to a constant value in a computer program. Next, a computer search was undertaken to establish which color, once a certain color Xp, Yp, Zp was selected in a given series, would give acceptable solutions for α and *t* if selected as Xq, Yq, Zq. . . . as concerns the computation of α, a difference of \pm .05 between αX, αY, and αZ was estimated to be tolerable. With smaller differences, too few colors of the Hesselgreen set yielded acceptable solutions for Xt, Yt, Zt. A second difficulty was posed by the fact that most computed α coefficients came out greater than .9 or smaller than .1. As a result, most *t* surfaces appeared either very transparent or almost opaque. Nonetheless, it has been possible to obtain excellent examples of balanced transparency where both the foreground color *t* and the background colors *A* and *B* were clearly visible, the latter two through the former. . . . Notwithstanding the above-mentioned precautions, in some cases perceptual transparency was not satisfactory, that is, layer *t*, superposed to regions *A* and *B*, did not appear homogeneous in its color and in its degree of transparency. . . . in other displays, a certain effort seemed necessary before an observer could

appreciate the color of the *t* surface. Sometimes, this color became apparent only after prolonged observation, even in stereoscopic conditions . . . However, the examples of balanced transparency produced employing the method illustrated above have demonstrated that the laws that govern transparency in colored displays are essentially the same as those that govern achromatic color transparency (Da Pos 1976*a*).

In a footnote, Da Pos added: "It should be noted, however, that the conditions uncovered in this work are necessary but not sufficient. When these conditions are absent, balanced transparency cannot be perceived. However, the presence of these conditions signals only the possibility, not the necessity, of perceiving balanced transparency" (Da Pos 1976*a*).

PARTIAL TRANSPARENCY IN COLORED DISPLAYS

To investigate partial transparency in colored displays, Da Pos (1977) employed a procedure similar to that adopted for studying complete and balanced transparency. Again, he took as starting points the mathematical model developed by Metelli and Heider's hypothesis that transparency results from a process of scission of a stimulus color (resulting from an additive mixture) in two component colors. In the case of partial transparency, however, only a single equation with one unknown is necessary. The unknown is α, the coefficient of transparency that indicates the proportion of the color in the region of superposition being assigned to the background layer (while $1 - \alpha$ is the proportion being assigned to the transparent layer). Although in complete and balanced transparency the color of the transparent layer also is unknown (and therfore a system of two equations is needed), in partial transparency the color of the transparent layer is known. It is the color of the nontransparent region of the rectangle on top. The only difference between the color of the figure in the transparent part and in the opaque part is that in the former the surface seems to be less dense. Because the configuration is reversible, in the sense that either figure can be viewed as on top of the other, two different equations can be computed depending on which figure is to become transparent.

Da Pos (1977) has investigated all the situations of partial transparency that could be obtained by keeping one color constant (the color of surface *A*) while systematically varying the other two colors. He has always obtained very compelling impressions of transparency. In some cases, however, he also noted that some colors, even if they corresponded to the values required by the

mathematical model, were less efficient than others in producing impressions of transparency. Based on this observation, he concluded: "From these examples and from other observations completed during the course of the present research, it seems that other factors are at play in colored-display transparency besides the conditions described in the mathematical model. Most likely, these factors have to do with the very nature of colors and require further clarification in future investigations."

METZGER'S OBSERVATION (PL. 38)

In his work, Da Pos employed the so-called Maxwell disk method. In this method of color mixing, disks having differently colored sectors are spun at fusion speed. Da Pos showed the rotating disks behind apertures corresponding to the superposition areas of the two rectangles. Exploring different color fusions, Da Pos noted that in some cases it was possible to have the impression of transparency even if the fusion color did not split into its two color components. This observation, which contradicts the hypothesis of G. M. Heider, is commented on as follows:

> This particular development of the present research is consistent with an early observation due to Metzger (1955). Metzger noted that it is possible to see as transparent a red surface over a green surface even if the area of superposition is blue. This kind of perceptual transparency is possible, according to the author, only when the two surfaces are seen to move relative to one another. Metzger did not provide an explanation for the observation, he only promised to devote further investigation to it. However, one should note that Metzger did not specify exactly what colors he had employed. In a repetition of his early observation, we have observed that impressions of transparency are stronger if, instead of using pure colors, one employs appropriate color mixtures. For instance, if instead of using pure red and pure blue one uses bluish red and reddish blue, then the impression of transparency is most compelling. This result may be explained if one recalls that, in the latter case, the color of one of the areas of superposition already contains a little bit of the color of the contiguous area. Due to this similarity of the colors of the two areas of superposition, it is more easily possible to see one region inside and through another. It remains to be explained why in this case one has an impression of transparency without color scission. Based on our own research, we can say that the phenomenon described by Metzger appears analogous to other situations that produce the impression of transparency, even though color

P is not split perceptually into color *t* belonging to the transparent surface and color *A* belonging to the background, provided that some conditions are met. . . . In order to account for these instances of transparency without color scission, which are to be considered as counterexamples to the hypothesis of G. M. Heider, we found it interesting to note the following. If the three colors involved are exchanged in position, so that the area of superposition is now filled with red or green, the perception of transparency is destroyed. This effect may be explained by hypothesizing that blue is chromatically in between red and green on a hypothetical color scale, so that a particular form of color scission can split it into red and green. Consistent with this idea, red and green do not behave in the same way, that is, they cannot be split into blue and green or blue and red. . . . Thus, blue only might allow this particular kind of scission to take place. This scission of blue into red and green requires appropriate color brightnesses, and might explain the impression of transparency in the above indicated situations (Da Pos 1977).

JACOB BECK

In his paper published in *Scientific American,* Beck (1975) proposed that colored transparency is seen when the color of the shared area is the product of subtractive mixing. In this, Beck differs from all previous investigators, who assumed additive mixing instead. In his article, Beck wrote:

An interesting example of color constancy involves transparent colors which depend on the perception of one surface behind another. . . . The area of intersection of each pair of colored circles on the left side of the illustration is the result of combining paints of the two colors. In each pair the area of intersection can be seen either as the mixture color when both colors are seen in the same plane or as the color of one circle seen through the transparent color of the other circle when the circles are seen in different planes. For example, one could see the area of intersection of the yellow circle and a blue circle as a green, or a yellow circle behind a transparent blue circle, or as a blue circle behind a transparent yellow circle. Although it is more difficult, one can see the area of intersection of the blue, yellow, and magenta circles as black or as blue, yellow, and magenta circles overlapping one another.

According to Beck, all this suggests that transparent colors are perceived as subtractive color mixtures, not additive. For instance, mixing blue and yellow light (a subtractive mixture) yields an achromatic color, white or gray. If the

Subtractive mixture

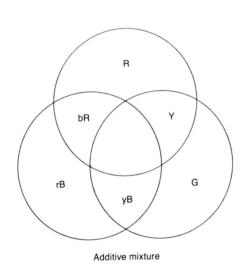

Additive mixture

perception of transparency follows the rules of subtractive mixing, then certain combinations of colors should not yield the perception of transparency. For instance, it should be impossible to see a yellow area as a transparent orange over a green surface. The subtractive character of the perception of transparency suggests that this phenomenon is due to our everyday experience with transparent surfaces. The fact that transparency is perceived according to the laws of subtractive color mixing implies that there is no need to posit a separation of the signals that reach the brain from the elementary color sensations sent by the receptor organs of the retina. To the contrary, transparency effects seem to derive from specific experiences in everyday color vision.

In a reply, Da Pos (1979*b*) examined the possibility that fusing a background color with the color of a transparent layer would yield subtractive color mixing, as proposed by Beck (1975), instead of additive mixing, as was maintained originally by G. M. Heider. Here is how he reported his results:

Recent investigations performed on the problem of subtractive vs. additive color mixing in colored transparency have led us to conclude that it is possible to perceive transparency in both cases. However, transparency with subtractive mixtures is only seen when the filtered color is very similar to the color that would result from an additive mixture, which is not always the case. If similarity is violated, the impression of transparency is completely lost. Moreover, if the two colors are only weakly similar, the impression of transparency is accordingly weak. A good example is the superposition of a yellow transparent layer to a blue background . . . if the region of superposition is gray (that is, if it is the sum of yellow and blue) the impression of transparency is compelling; but if the region of superposition is green (as it should be with a yellow filter placed in front of a blue background, yielding a subtractive mixture) then the impression of transparency is lost and one sees only three opaque regions, respectively yellow, blue, and green.

According to Da Pos, transparency follows the laws of additive, not subtractive, color mixing, because it results from a perceptual, not a physical, process. This process has to do with the mechanisms of visual perception, not with the purely physical process of filtering light. Subtractive color mixtures seem to yield the impression of transparency only as a consequence of experience with filters. Thus, the conclusion seems warranted that the perception of transparency is not due to the physical transparency of the objects involved. Rather, the

perception of transparency seems to be due mainly to the fact that a particular arrangement of visual stimuli is consistent with conditions dictated by the operating characteristics of the visual apparatus, best described by perceptual laws.

In conclusion, let me summarize the positions of Da Pos and Beck. Da Pos makes several claims: (1) The fusion color in perceptual transparency must result from an additive mixture of the two colors. (2) Transparency may also be perceived in displays having subtractive mixtures in the region of superposition, provided that the resulting hue is similar to the hue that would result from an additive mixture, which is not always the case. For instance, the additive mixture of blue and yellow yields white-gray, while the subtractive mixture yields green. According to Da Pos, in this example the additive mixture yields green. According to Da Pos, in this example the additive mixture yields the perception of a yellow transparent layer, while the subtractive mixture yields the perception of three opaque surfaces. (3) Based on his experimental results within the framework of Metelli's mathematical model adopted to encompass colored-surface transparency, Da Pos concluded that color conditions are necessary but not sufficient to account for perceived transparency, even though it is possible to generate impressive demonstrations of transparency. (4) Based on his experiments in partial transparency, Da Pos concluded that in some cases the perception of transparency is impeded by factors that go beyond those encompassed by the mathematical model and that are probably due to the very nature of colors. These factors still await investigation. For instance, Da Pos admits that in some instances it is possible to achieve the impression of transparency even though the stimulus color is not split into its two components, as one would expect based on Heider's theory of scission.

Beck makes the following claims: (1) The fusion color in perceptual transparency is the product of a subtractive mixture. Thus, transparency should be perceived if the region of superposition between blue and yellow is green, but not if it is gray. (2) In colored-surface transparency, the fusion color has to be a subtractive mixture because the perception of transparency is due to the effect of "past experience" on the perception processes.

THESIS OF THIS STUDY

I have devoted most of my life to the study of painting. Having developed an interest in the expressive possibilities offered by transparency in colored dis-

plays, I have sought to deepen my understanding of the laws that might govern it. In this quest for suitable conceptual instruments, I have found a valid theoretical framework in the theory of color mixtures developed by Arnheim in *Art and Visual Perception* (1954).

It must be admitted that many artists (cubists, expressionists, abstractionists) have solved the problem of colored partial transparency pragmatically, by mixing the pigments used for the contiguous regions in the region of superposition. In this way, they produced a subtractive mixture. However, this solution cannot be satisfactory, for two reasons. The first reason is artistic. With subtractive mixtures of pigments, the perceptual results are very predictable, for they are constrained within the limits of a filtering process. Thus, there is no room for the imagination of the artist. The second reason is technical. While artists were using transparency as an expressive device, students of perception were investigating the bases of complete and balanced transparency, eventually reaching the conclusion that four regions had to be used instead of three. Although at the time a solution was found solely for achromatic-color transparency, the result demonstrated that there was room in the approach for research that could possibly lead to new developments. Furthermore, the process of mixing the two contiguous pigments to produce the color of the region of superposition has a serious drawback. If the two component colors are complementary, the resulting mixture is perceptually achromatic.

Based on Heider's hypothesis that the color of the shared area (the stimulus color) in perceptual transparency is the result of additive mixture, Da Pos claimed that with blue and yellow surfaces transparency is perceived only when the shared area is white or gray, while as already noted, there is no perception of transparency if the region of superposition is green. This is exactly the opposite of what is reported by painter and color scholar Josef Albers (1963) in his well-known *Interaction of Color* and by Beck in his *Scientific American* paper (1975). On this issue, I would like to make an essential point: An achromatic hue cannot be split perceptually into two chromatic hues. To split the color of the shared area into its two component colors, it is necessary that this color be made by what I call a visual chromatic mixture. By this I simply mean a hue that appears as a mixture, whether or not it is actually a mixture. For instance, pure red, a fundamental primary, is visually a nonmixture because it appears as a pure color, but physically it is made of a mixture of red and yellow light. If from this physical mixture we subtract yellow, we are left

with a pure light, but to the eye this pure light becomes a visual mixture. As a matter of fact, in these conditions the human eye sees red with an addition of blue, the color that we call bluish red.

Thus, the thesis of the present investigation is that the phenomenon of perceptual transparency is independent of physical reality. Transparency is founded on visual reality, which, as we have seen, does not overlap with physics. In this view, the issue of additive versus subtractive color mixing is irrelevant.

My thesis purports to demonstrate that, all other conditions being equal (form, topology, lightness, and color), the eye splits visual chromatic mixtures into their component colors, thus producing the perception of transparency and "seeing" the two colors on different planes. If the visual mixture is composed of two pure colors, then the splitting occurs between these two pure colors only. If the mixture also contains a third color, then the splitting again is between the pure colors, but the third color becomes a remainder. For instance, a stimulus color composed of red and blue can only be split into red and blue. Suppose, however, that both these colors are contained in a mixture with another color. For instance, blue might be contained in green and red might be contained in orange. Rather than saying that the blue-red of the stimulus color has been split into green and orange, then, one should say that the stimulus color has been split into the red and blue respectively present in orange and green.

NECESSARY CONDITIONS FOR THE PERCEPTION OF COMPLETE TRANSPARENCY IN COLORED DISPLAYS

1. Four regions need to be considered, two as parts of the transparent figure and two as part of the background.

2. The transparent figure must be composed by two visual chromatic mixtures. That is to say, the colors of the two parts of the transparent figure must appear as a mixture to the average observer, independently of their physical components.

3. Because the perception of transparency implies a splitting into two colors, one assigned to the transparent figure and the other to the background, this split will take place most easily if the shared areas are made of unbalanced mixtures. Balanced mixtures, such as green (BY), orange (YR), and violet (RB), because of their nature have a tendency to resist splitting.

4. The color that the two mixtures have in common becomes the local color of the transparent layer.

5. The other two colors in each of the two mixtures become the colors of the background.

6. To produce the impression of balanced transparency, it is necessary that the color to be assigned to the transparent layer be present in both mixtures in the same quantity. It must be either dominant in both, or subordinate in both.

7. If the common color is present in different quantities in the two mixtures that take part in the transparent figure, then for the background we must use a mixture that will balance the transparency of the superposed figure by assimilation of the excess color. Consider, for instance, the yR-rB pair when the colors of the background are yellow behind yR and blue behind rB. The common color of the transparent figure is red, but the mixture is unbalanced, for red is dominant on one side and subordinate on the other. If we add one unit of red to the background, we obtain reddish yellow. Then, on the transparent layer one part of the red on the yR region will appear to belong to the background, and the two regions of the transparent figure will appear balanced.

8. In each of the two mixtures the role of the common color provides an indication about the degree of transparency. If the common color is subordinate in both mixtures, the figure is very transparent, for we see a lot of the color in the background and very little of the color of the figure. If the common color is dominant, then the figure is more opaque than transparent, for we see a lot of the color of the figure and relatively less of the color of the background.

9. It is possible to produce a transparency display starting from the background colors. Suppose, for instance, that the background colors are yellow and blue. The transparent figure will have to be red, for if it were yellow, it would be invisible over the yellow background, while if it were blue, it would be invisible over the blue background. Thus, to achieve the impression of transparency in these conditions we need to add red, in equal amounts, to both background colors in the regions of superposition.

10. The two colors of the background may also be made of mixtures. If we choose two primary colors, we can add a certain proportion of a third color to these two colors, turning them into unbalanced mixtures having the subordinate color in common. Over those background mixtures each region of the

transparent figure will be made of another portion of the common color added to the underlying mixture. For instance, let the background mixtures be yellowish blue and yellowish red. Yellow, the common color, will be added to yellowish blue, turning it into bluish yellow or green, and to yellowish red, assuming the appearance of reddish yellow or orange. These two new mixtures, if connected to give a sense of figural unity and adjusted to the necessary lightness conditions, will give an impression of transparency. The figure will look very transparent, as only a part of yellow will be experienced as belonging to the transparent figure, whereas the other part will be assimilated by the background.

Of course, the chromatic conditions outlined here are to be coupled with the appropriate conditions of form, topology, and lightness difference already discussed.

THE FOUR KINDS OF COLOR JUXTAPOSITIONS AND THEIR QUALITIES IN PERCEPTUAL TRANSPARENCY

Let us examine now the transparency effects that can be produced by means of the juxtaposition of color mixtures analyzed by Arnheim.

SHARED SUBORDINATE (PL. 35)

As we have seen, this kind of color pairing is defined by the complementarity of its members. In a shared-subordinate pairing, two primaries are each mixed with a lesser part of the third primary. As noted earlier, because of the insertion of the third color the two contiguous hues are subjected to an equal displacement in their perceived depth. Given that they are phenomenally moved in depth in the same direction, these two hues tend to be perceived as coplanar. This, as well as the quantitative similarity of the third color in the mixtures, makes this kind of juxtaposition particularly suitable for playing the role of a transparent layer. To be even more precise, the common color in the two mixtures is easily seen as the local color of the transparent layer, because it is present in equal amounts in both. In this fashion, the chromatic unity of the layer is readily achieved, and the other two colors, being present in the mixtures in greater proportions, become the colors of the background.

Consider the example in plate 35, based on the mixtures depicted in the lower part of plate 23. The transparent layer is painted using the mixtures reddish blue (rB) and reddish yellow (rY), so that the common color, the shared

subordinate, is red. The two dominant colors in the mixtures are respectively blue and yellow. Thus, the background appears blue behind the reddish blue area, and yellow behind the reddish yellow area. The transparent layer appears red. Essentially, the transparent layer takes on the color that unites the two mixtures, their common color, whereas the background takes on the colors that are different in the two mixtures. The shared part is split from the divergent parts. The chromatic whole, however, is bound dynamically because of the action of complementarity. The impression is one of balanced transparency, for the amount of shared color is equal in the two parts of the figure. Furthermore, one sees a lot of transparency, because a greater part of the color is assigned to the background than to the figure. In the same way, the water in a glass appears very transparent if one stirs in a minimal amount of paint, so that the color of the background is easily seen. However, the water becomes much less transparent if more color is added, so that the color of the background becomes difficult to discern. (This example is due to Metelli.)

SHARED DOMINANT (PL. 36)

In this kind of juxtaposition of mixtures, the shared color takes on a dominant role in both components. Thus, the shared color is present in equal amounts, and in greater proportion than the other two colors. This large quantity of shared color is assigned to the transparent layer, which acquires, by means of its chromatic homogeneity, a high degree of visual unity. However, one has the feeling of a figure that is not very transparent, for most of the color is assigned to the figure itself and relatively less to the background. Also in this case, the transparent figure appears balanced, because the shared color is present in equal amounts in both parts of the layer.

COMPLETE INVERSION (PL. 37)

So far, we have discussed the two kinds of juxtapositions that are based on similarity. In these juxtapositions, the shared color plays the same role in the two mixtures. Let us examine now the other two tertiary juxtapositions, which are based on an inversion of the role played by the shared color. In the first juxtaposition of this kind, which Arnheim called "complete inversion," only two of the three primaries are present, each taking the role of dominant in one mixture and of subordinate in the other. In the other, which Arnheim called "partial inversion," all three colors are present and one of them inverts its role.

Using a complete inversion in a transparency display makes it possible to choose which of the two colors in the mixtures will become the color of the transparent layer. This is so because in this kind of juxtaposition there are two shared colors, not just one as in all other kinds. However, because each color symmetrically inverts its role in the two mixtures, the degree of transparency would tend to appear unbalanced in the two parts of the figure unless one applied some correction by modifying the background colors accordingly.

For instance, if one mixture is made with two parts of yellow and one part of blue, to yield a complete inversion the second mixture will have to be made with two parts of blue and one of yellow. Now, whether the transparent figure appears blue or yellow (depending on the colors in the background), it will still be true that in one of its parts the transparent color will be subordinate and in the other, dominant. Since this implies that the color will be present in unequal amounts in the two parts, the degree of transparency would have to be different in those two parts. Thus, unbalanced transparency would result, unless one modified the background behind the part with the greater proportion of color. This modification would entail changing the mixture in that part of the background, to make it capable of assimilating the color in excess in the figure.

One example is provided in plate 37, which demonstrates how the color of the transparent layer can change as a function of the background colors, even though the same mixtures are used for its parts. At the middle left, the display has a transparent figure painted yellowish blue (yB) and bluish yellow (bY) over a background painted green (By) and yellow (Y). The green in the background assimilates one of the two units of blue contained in yellowish blue as well as the single unit of yellow. Thus, a single unit of blue remains for the transparent layer. The yellow in the second region of the background assimilates the yellow contained in bluish yellow. Thus, one unit of blue also remains for the transparent layer. As a consequence, the transparent figure appears blue and balanced, for blue is present in equal amounts in the two regions of the transparent layer. In the upper right of plate 37, the display has a transparent figure painted yellowish blue (yB) and bluish yellow (bY) and a background painted blue (B) and green (BY). The blue contained in yellowish blue is assimilated by the blue background, while the green of the second background region assimilates the unit of blue and one of the two units of yellow that are contained in the bluish yellow of the transparent figure. Thus, one unit of yel-

low is left for each part of the transparent figure, which therefore appears yellow and balanced.

In this kind of juxtaposition, also, there is a change in the role and therefore in the amount of a color shared by the two mixtures. As already discussed in the preceding section on complete inversions, the task here is to counterbalance the asymmetry in the amount of the shared color by changing the colors contained in the background mixtures.

Consider the display on the upper left of plate 39. The two mixtures, yellowish red (yR) and bluish yellow (bY), both contain yellow, but in different amounts and therefore in different roles. The background should be painted with the two colors that would remain once one subtracted from the mixtures their shared color, which is yellow. These colors are red and blue. However, if one used blue for one part of the background, one unit of yellow would remain in bluish yellow (bY), and this would set the whole out of balance. Thus, it is necessary to add to blue one unit of yellow and use yellowish blue (yB) for that part of the background. The resulting situation will be as follows: The two units of red in the part of the transparent figure painted yellowish red (yR) will be seen as belonging to the background; the remaining unit of yellow will unite with the other unit left in bluish yellow (bY). In this way, the transparent figure will appear yellow and balanced.

MULTIPLE TRANSPARENCIES

Starting from the principles described earlier, we can conceive of painting several transparent layers on top of one another. Although this would yield black, if the process were akin to a subtractive mixture, or white if it were like an additive mixture, based on the principles of visual mixtures we can produce the impression of multiple layers painted with different mixtures and seen as transparent, each on top of another on different depth planes. In this case, each layer is seen as transparent only relative to the layer immediately under it, which can be painted either with two mixtures or with one mixture and a pure color. The series of multiple transparencies could end up with a juxtaposition of two pure colors, which should appear as an opaque background behind the superposed layers.

In this fashion, one could plan a complete sequence of transparent layers

to be accumulated, so to speak, over the background juxtaposition of a pure color with a mixture containing that color. Here is an example of such a sequence of transparent layers. *Background:* a pure color and a mixture that contains that color. *First overlying layer:* a complete-inversion pairing. *Second overlying layer:* a shared-subordinate pair. *Third overlying layer:* a shared-dominant pair. Six combinations of this sequence are possible, starting from the following pairings for the background: red and orange, red and violet, blue and green, blue and violet, yellow and green, yellow and orange.

METZGER'S OBSERVATION, ONCE MORE (PL. 38)

According to the hypothesis of G. M. Heider, blue should not function as a stimulus color for a transparent layer to be seen over a background painted red and green. This is because blue is not an additive mixture of the latter two colors. However, based on the observation described by Metzger and repeated by Da Pos, we know that blue *can* be used for a transparent layer in these conditions. This fact is very surprising for the student of transparency, for it provides direct evidence against Heider's hypothesis. To save the hypothesis, Da Pos is ready to assume that blue might be chromatically intermediate between red and green. However, this assumption seems far-fetched, because it contrasts with our present conceptions of color and color relations.

Arnheim pointed out that a distinction is in order between two different phenomena: *transparency* proper and *double superposition.* The latter is the condition in which two partly overlapping shapes are both seen as complete, but without an impression of transparency. The shared area, in these cases, is experienced as belonging to both forms. However, no perceptual scission takes place. This is a paradoxical situation, but one that is perfectly possible perceptually. Double superposition might be taken as an intermediate phenomenon due to a specific relationship between form factors, which support transparency, and color factors, which do not. Double superposition has often been employed in modern art (think, for instance, of Miró). If this distinction is valid, then Metzger's paradoxical observation might be accounted for as an instance of double superposition, not to be confused with transparency.

Arnheim's distinction certainly calls for a reanalysis of Metzger's observation. However, before we reclassify Metzger's phenomenon as an instance of double superposition, let us examine whether the necessary conditions for colored transparency listed in the present investigation apply to the display used

by Da Pos. Because the conditions proposed here do not require that the difference between additive and subtractive mixtures be respected, they might provide an account of the phenomenon.

First of all, recall that Da Pos used mixtures instead of pure colors for the parts of the transparent figure. Specifically, he employed bluish red and reddish blue instead of simply red and blue. These mixtures are produced by adding to each of the two colors a smaller amount of the other. The resulting juxtaposition is a complete inversion. The experiments reported in this book have shown that complete inversions are "converging" pairings. Therefore, this quality reinforces figural unity in the transparent layer.

According to my thesis, in order to see transparency it is necessary that the background color be seen "through" the reddish blue region, and this can only happen if the background is *one of the two colors* in the overlying mixture. Now, the colors that take part in the stimulus mixture are blue, which is dominant (two parts), and red, which is subordinate (one part). One of these two colors must remain available for the color of the transparent layer, whereas the other must become the color of the background or at least a part of it. But now note that *visually* green is a mixture of yellow and blue. Thus, the blue part of the mixture can become a part of the green background, which completes the scission: Some of the blue part is assimilated by the background, while the remaining part of red is united with the bluish red of the contiguous mixture. Note, however, that the assimilation is not complete, for the proportion of blue *visually* present in green is less than the proportion of blue actually present in reddish blue. Therefore, a certain amount of blue also remains on the transparent layer, which is unified with the unit of bluish in bluish red. Finally, the part of yellow visually contained in green is simply not perceived. Because it has no perceptual use, it becomes a visual remainder.

If this reasoning is correct, then at least under the conditions of the replication performed by Da Pos the observation of Metzger should be taken as a true instance of perceptual transparency, not of double superposition. Supporting the thesis proposed here, in the display described by Metzger there is indeed a scission of two colors. However, these are the colors that are part of the stimulus mixture *visually,* not physically, and the scission takes place according to a purely visual logic. There is no need to assume that blue might be an additive mixture of red and green. We know that the additive mixture of red and green yields yellow, not blue. And yellow could not split into red and green, nor into

any other pair of colors, for yellow is a pure color, which by definition cannot be split.

A necessary conclusion results. Heider's hypothesis is not sufficient to account for colored transparency, because it works only if the stimulus color is a visual mixture and if the pure colors in the mixture are found in the contiguous hues, either pure or in other visual mixtures. According to my view, when these conditions do not hold, Heider's hypothesis is not valid. Let us recall the opinion of Da Pos (1977) on this issue: "From these examples and from other observations completed during the course of the present research, it seems that other factors are at play in colored-display transparency besides the conditions described in the mathematical model. Most likely, these factors have to do with the very nature of colors and require further clarifications in successive investigations." And also: "It should be noted . . . that the conditions described by the systems of equations . . . are necessary but not sufficient. When these conditions are absent, balanced transparency cannot be perceived. However, the presence of these conditions signals only the possibility, not the necessity, of perceiving balanced transparency."

PERCEPTUAL TRANSPARENCY IN PAINTING

In *Art and Visual Perception,* Arnheim (1954) discussed transparency effects in art. He pointed out that "to avoid confusion, the word 'transparency' should be employed only when the impression of 'seeing through' is deliberately sought by the artist. The idea that two things might appear in the same position of the visual field is sophisticated. One can find it only in advanced forms of visual art, for instance, in the Renaissance. Modern artists, for instance Lyonel Feininger and Paul Klee, have made large use of this procedure for dematerializing physical substances and for breaking spatial continuity." The use of perceptual transparency in pictorial compositions allows us to create a special kind of contrast between opaque and transparent surfaces. The former appear solid, while the latter take on a somewhat fluid appearance. The appearance of the color of the transparent surface also changes, even though the retinal stimulation remains the same.

This effect is confirmed by specific experiments in studies of perception. Kanizsa (1980), for instance, showed that a context suitable for producing the transparency effect can influence an area having the same stimulation, making it perceptually different. In one of his demonstrations a central rectangle,

which is perceived as transparent, appears whiter than the background even though they are physically identical whites. And Da Pos (1977) noted that in partial transparency the transparent part of a figure appears less dense than the other part, which looks opaque.

Another effect due to perceptual transparency is the ability to confer balance to forms that, by themselves, lack stability. Stabilizing unstable forms, such as disks, usually requires borders provided by lines. However, a stabilization can also be attained by means of a transparency effect. In this case, a disk can become stable if a structure emerges, beyond its form, and blocks its instability. Finally, another interesting transparency effect is the apparent depth caused by seeing multiple transparent layers. These depth effects are independent of the use of linear or aerial perspective.

There are several examples of the use of perceptual transparency in modern painting: Feininger, Klee, Kandinsky, Man Ray, Albers (who also wrote about transparency in *Interaction of Color* [1963]), Itten, Moholy-Nagy, El Lissitzky, Stanton Macdonald Wright. In Italy, Atanasio Soldati and Manlio Rho both used transparency effects. Plates 47–50 display works by Klee, Kandinsky, Lissitzky, and Moholy-Nagy.

In all these works, subtractive mixtures are used most often for the shared area of the superposed surfaces. The two contiguous hues are simply mixed together, an operation that is congenial to the painter. In some cases, however, a different pigment is used—for instance, in some works by Soldati. Further. the lightness of the shared color tends to conform to Talbot's law. Thus, the lightness of the shared area is approximately a weighted sum of the lightnesses of the other two areas. Because most artistic experiments on transparency date back to the first decades of the twentieth century, we find that only three areas are used, not four. Therefore, most effects are of partial transparency. We can say that in this field often the intuitions of visual scientists have preceded those of visual artists. As we have seen, only after 1955 did it become possible, thanks to Metelli, to account for complete transparency with four regions in achromatic color displays. More generally, investigations of perception have mostly remained confined to universities. They are not studied in the schools of fine arts, and therefore have not reached art scholars. One exception to this rule was the exciting parenthesis of the Bauhaus. However, even if some notions on the psychology of form are inserted in the syllabi of art courses, at

tion and more than superficially informed of issues in the psychology of perception.

A final possibility for artistic expression becomes available if we achieve transparency effects with opaque colors (not with diluted colors, which form a physically transparent veil). This possibility, which I have investigated at great length, is offered precisely by the fact that transparency in this case does not correspond to physical reality. Thus, it is possible to plan it according to a logic that does not have to do with reality and that can also have absurd consequences. For instance, we can produce paradoxical effects of reversibility, analogous to the "impossible solids" investigated by psychologists in the space domain. (These reversals have nothing to do with the ambiguity of two superposed line drawings.) A transparent layer may appear as such in one of its parts, but may appear opaque elsewhere. As a consequence, we will have the impression of seeing another pattern behind the transparent part, but this impression will change into one of amodal completion behind the opaque part. In the latter case, we will see an underlying pattern that "continues behind" the opaque surface according to "good continuation" and "similarity." Therefore, it becomes possible to arrange reversible depth orderings, as in the case of my painting reproduced in plate 34, where the directly visible part of the opaque rings is in contrast with the different structure seen by means of transparency.

10

An Anomalous Case of Perceptual Transparency

WHEN DISCUSSING complete transparency with colored displays, I demonstrated that perceiving transparency implies the splitting of the two color mixtures composing the transparent layer. During this process of scission the common color is isolated and is seen as the local color of the transparent layer, while each of the other two colors is identified with one of the colors of the background. Through this process each color of the background becomes recognizable as a specific hue.

However, there is no reason why "seeing through" colored transparent layers should imply recognizing the color of the visible background. In the experiments described in this chapter I show that if observers are presented with instances of transparency where this requirement is not met, they do not realize that the background color is not recognizable. Apparently, this is not a necessary condition for perceptual transparency. The hypothesis I would like to propose can be summarized as follows: Normally, in transparency there is a scission between, say, a subordinate color of the transparent layer and a dominant color of the background (for instance, reddish yellow on red). Why, in the presence of the same general conditions, should not a similar scission take place between a subordinate of the background and the same dominant of the transparent layer? That is, why should it not be possible to invert the roles? If transparency is still perceived in the latter conditions, then we must conclude that it is not necessary to recognize the background color through the transparent figure.

The examples discussed in this chapter are reproduced in plate 40. They divide into two groups. The first group, depicted in the left column of the plate, pl. consists of transparency displays made of complete-inversion pairs. The second group, depicted in the right column, consists of displays made of shared-dominant pairs. In the latter type of juxtaposition the subordinate colors of the mixtures on the transparent layer are assimilated by the subordinate colors of the mixtures on the background.

EXAMPLE A

Background: Bluish red (bR) and yellowish red (yR). *Transparent figure:* Yellowish blue (yB) over bluish red, bluish yellow (bY) over yellowish red (complete inversion).

Analysis: Part of the dominant yellowish blue is assimilated by the blue

subordinate in the bluish red mixture, while the yellow dominant in the bluish yellow mixture is assimilated partly by the background, where yellow is subordinate. In each mixture, one unit of yellow and one unit of blue are left for the transparent layer. Thus, the transparent layer is greenish and balanced, for it has the same degree of transparency on both areas.

EXAMPLE B

Background: Dark bluish yellow (bY) and light reddish yellow (rY). *Transparent figure:* Reddish blue (rB) and bluish red (bR) (complete inversion).

Analysis: In the reddish blue mixture, one of the two units of blue is assimilated by the unit of blue on the background. Similarly, in the other area one unit of red in the bluish red mixture is assimilated by the red subordinate of the background. In this way, one unit of red and one unit of blue remain in each area of the transparent layer. Thus, the figure appears purple and balanced on both areas. This transparent figure is united strongly because its colors form a harmonic pair.

EXAMPLE C

Background: Reddish blue (rB) and bluish yellow (bY). *Transparent figure:* Yellowish red (yR) and reddish yellow (rY) (complete inversion).

Analysis: One unit of red from the yellowish red mixture is assimilated by one unit of red from the reddish blue on the background. In the other two superposed contiguous areas, one unit of yellow from the reddish yellow mixture is assimilated by one unit of yellow in the bluish yellow mixture. One unit of red and one unit of yellow remain in each of the two areas of the transparent layer. Thus, the transparent layer looks orange. This figure also looks unified as it is composed of a harmonic and balanced pair.

EXAMPLE D

Background: Bluish red (bR) and reddish blue (rB). *Transparent figure:* bluish yellow (bY) and reddish yellow (rY) (shared dominant).

Analysis: There are one unit of blue and one unit of red in the two areas of the background. These are assimilated by the units of blue and red which are contained in the mixtures of the transparent layer. Thus, two units remain in each part of the figure, which appears yellow and balanced.

EXAMPLE E

Background: Dark bluish yellow (bY) and yellowish blue (yB). *Transparent figure:* bluish red (bR) and yellowish red (yR) (shared dominant).

Analysis: The two subordinate colors on the transparent layer, blue and yellow, are assimilated by the same subordinate colors in the mixtures of the background. In each of the mixtures on the transparent layer, two units of red remain. Thus, the transparent layer will appear red and balanced.

EXAMPLE F

Background: Dark reddish yellow (rY) and yellowish red (yR). *Transparent figure:* reddish blue (rB) and yellowish blue (yB) (shared dominant).

Analysis: There are two subordinate colors in the mixtures of the transparent layer—red and yellow. One unit of each is assimilated by the same subordinate colors contained in the two mixtures of the background. Two units of blue remain in each area of the transparent layer. Thus, the layer looks blue and balanced.

In conclusion, we should note that it is not possible to obtain this kind of transparency if we use shared-subordinate pairs, that is, harmonic juxtapositions. The reason is the following: after we have subtracted the subordinates, only two opposite colors remain in each member of the pair. Thus, the transparent layer cannot have a common color. Of course, we could still assimilate the dominant colors, so that the subordinate remains as common. But this would be an instance of the standard case of transparency where the background color becomes identifiable. For the same reason, we cannot achieve the kind of transparency discussed in this chapter using partial-inversion pairings.

I propose to call the perceptual effect described here *anomalous transparency.* Investigators have used the term *partial transparency* when discussing displays where a figure looks transparent only in the superposed region, and opaque in the other. Partial transparency should not be confused with anomalous transparency. In partial transparency, the color of the transparent layer is directly visible in the area that looks opaque. In anomalous transparency, however, as in standard complete transparency, the color of the transparent layer is always part of a mixture and is seen only after a split takes place between the figure and the background components.

In the examples of complete transparency in colored displays discussed in chapter 9, the classification of color juxtaposition proposed by Arnheim was used as a method for investigating color. In the examples proposed here, we are forced to take into account also the specific qualities of those juxtapositions and their relations to color harmonies.

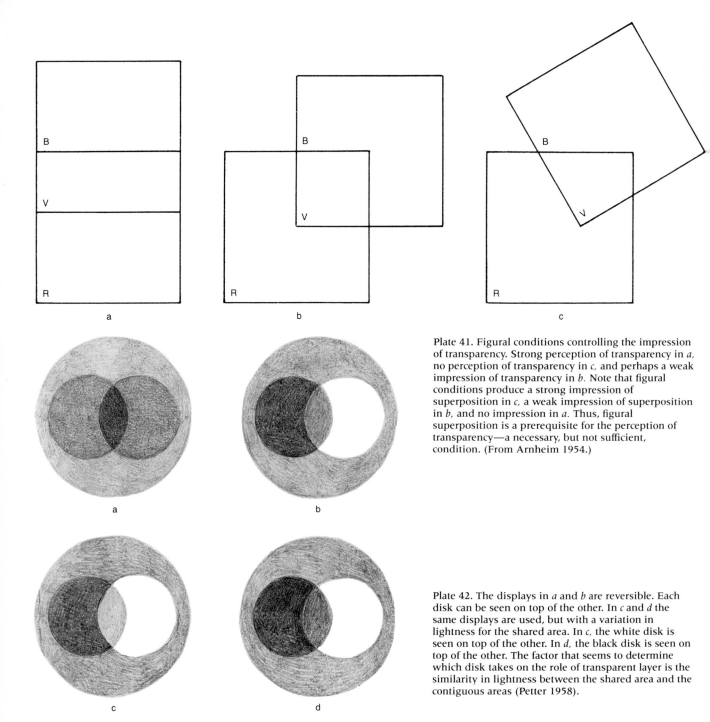

a

b

c

a

b

Plate 41. Figural conditions controlling the impression of transparency. Strong perception of transparency in *a*, no perception of transparency in *c*, and perhaps a weak impression of transparency in *b*. Note that figural conditions produce a strong impression of superposition in *c*, a weak impression of superposition in *b*, and no impression in *a*. Thus, figural superposition is a prerequisite for the perception of transparency—a necessary, but not sufficient, condition. (From Arnheim 1954.)

c

d

Plate 42. The displays in *a* and *b* are reversible. Each disk can be seen on top of the other. In *c* and *d* the same displays are used, but with a variation in lightness for the shared area. In *c*, the white disk is seen on top of the other. In *d*, the black disk is seen on top of the other. The factor that seems to determine which disk takes on the role of transparent layer is the similarity in lightness between the shared area and the contiguous areas (Petter 1958).

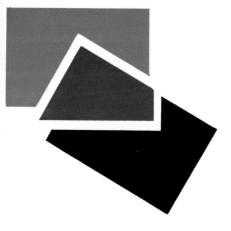

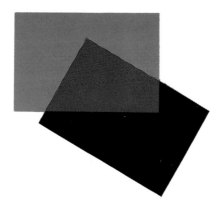

Plate 43. Mosaic method of producing a visual impression of transparency with opaque paper. The impression of transparency is strongest in the central area where the two rectangles intersect. The method is due to W. Metzger.

Topological and figural constraints cooperate in producing an impression of transparency.

Topological constraint: Each of the areas that unify to form the transparent layer is in contact only with the other area that unifies and with one of the other areas. The figural constraint is also favorable in this case.

The lightness difference between the two regions of the transparent figure is greater than the difference between the two regions in the background, a condition that prevents the perception of transparency.

The perception of transparency is impeded because the lighter region of the transparent figure lies over the darkest region of the background, whereas the darker region of the transparent figure lies over the lighter region of the background.

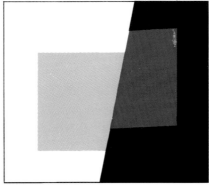

Topological and figural constraints prevent the perception of transparency.

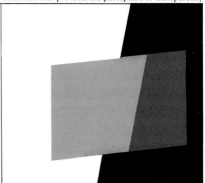

The topological constraint is violated. Despite the figural unification, there is no perception of transparency. (From Kanizsa 1981.)

Plate 44.

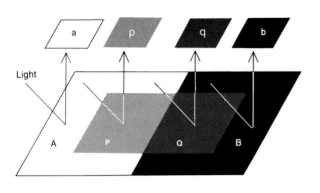

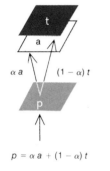

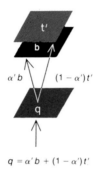

$p = \alpha a + (1 - \alpha) t$

$q = \alpha' b + (1 - \alpha') t'$

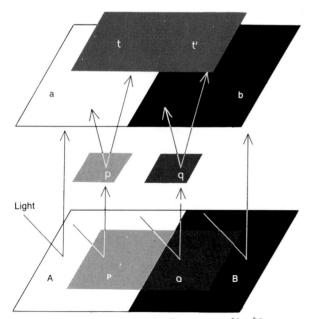

$t = t'$ E $\alpha = \alpha'$ then $\alpha = \dfrac{p - q}{a - b}$, $t = \dfrac{aq - bp}{(a + q) - (b + p)}$

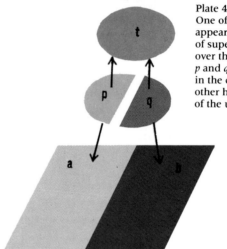

Plate 45. Partial transparency. One of the two rectangles appears transparent in the area of superposition but opaque over the background. The colors p and q split, on the one hand, in the color t on top and, on the other hand, in the colors a and b of the underlying background.

Plate 46. From Metelli (1974).

Left half $\alpha = \dfrac{p - t}{a - t}$				Right Half $\alpha = \dfrac{q - t}{b - t}$		
$t > p > a$			E	$t > q > b$		
$a > p > t$			E	$t > q > b$		
$t > p > a$			E	$b > q > t$		
$a > p > t$			E	$b > q > t$		

Plate 47. Paul Klee, *The Step*. 1932. Painted on jute (71 × 55.5 cm). Collection of Felix Klee, Bern.

Plate 48. Vassily Kandinsky, *Composition*, 1924 (35 × 25 cm). Private collection, Rome.

Plate 50. *Above* László Moholy-Nagy, *A 19*, 1927 (74 × 95 cm). Private collection, Bergamo.

Plate 49. *Left* El Lissitzky, *7 A*, 1920 (18 × 14 cm). Kunstmuseum, Basel.

BIBLIOGRAPHY

ALBERS, J. 1963. *Interaction of color.* New Haven: Yale University Press.

ARNHEIM, R. 1954. *Art and visual perception: A psychology of the creative eye.* Berkeley and Los Angeles: University of California Press.

———. 1969. *Verso una psicologia dell'arte.* Turin: Einaudi.

———. 1969. *Visual thinking.* Berkeley and Los Angeles: University of California Press.

BECK, J. 1975. Surface color. *Scientific American* 233:62–75.

———. 1978. Additive and subtractive color mixture in Color Transparency. *Perception and Psychophysics* 23:256–67.

BOZZI, P. 1975. Osservazioni su alcuni casi di transparenza fenomenica realizzabili con figure a tratto. Pp. 88–110 in *Studies in perception: Festschrift for F. Metelli.* Florence: Martello.

BRÜCKE, F. 1866. *Des couleurs au point de vue physique, physiologique, artistique et industriel.* Paris.

CHEVREUL, E. 1864. *Des couleurs et de leur application aux arts industriels à l'aide des cercles cromatiques.* Paris.

DA POS, O. 1976*a.* Perceptual transparency: Additive or subtractive chromatic mixture? *Atti e Memorie dell'Accademia Patavina di Scienze, Lettere e Arti* 88:185–93.

———. 1976*b.* Contributo teorico sperimentale alla percezione della trasparenza equilibrata con colori. *Atti dell'Istituto Veneto di Scienze, Lettere ed Arti* 134:701–22.

———. 1977. Contributo teorico-sperimentale alla percezione della trasparenza parziale con colori. *Atti dell'Istituto Veneto di Scienze, Lettere ed Arti* 135:47–70.

ELLIS, W. D. 1939. *A sourcebook of Gestalt psychology.* New York.

FUCHS, W. 1923. On transparency: The influence of form on the assimilation of colors. *Ellis* 71:89–103.

GOETHE, J. W. 1979. *La teoria dei colori.* Milan: Il Saggiatore.

HEIDER, G. M. 1933. New studies in transparency, form, and color. *Psychologische Forschung* 17:13–56.

ITTEN, J. 1965. *Arte del colore.* Milan: Il Saggiatore.

KANDINSKY, W. 1973. *Tutti gli scritti.* 2 vols. Milan: Feltrinelli.

KANIZSA, G. 1955. Condizioni ed effetti della trasparenza fenomenica. *Rivista di Psicologia* 69:3–19.

———. 1980. *Una grammatica del vedere.* Bologna: Il Mulino.

———. 1981. Organization in vision. Pp. 151–69 in *Essays on Gestalt perception*. New York: Praeger.

———. 1984. *Fenomenologia sperimentale della visione*. Milan: Angeli.

KLEE, P. 1959 and 1970. *Teoria della forma e della figurazione*. 2 vols. Milan: Feltrinelli.

KOFFKA, K. 1935. *Principles of Gestalt psychology*. London: Routledge and Kegan Paul.

LAMBERT, J. H. 1772. *Beschreibung einer mit dem Calauschen Wachse ausgemalten Farbenpyramide*. Berlin.

METELLI, F. 1970. An algebraic development of the theory of perceptual transparency. *Ergonomics* 13:59–66.

———. 1974. The perception of transparency. *Scientific American* 230, no. 4:90–98.

METZGER, W. 1955. Über Durchsichtigkeits-Erscheiunungen (Vorläufige Mitteilung). *Rivista di Psicologia* (fascicolo giubilare): 187–89.

MUSATTI, C. 1924. Sui fenomeni stereocinetici. *Archivio Italiano di Psicologia* 3:105–20.

———. 1953. Richerche sperimentali sopra la percezione cromatica. *Archivio di Psicologia, Neurologia e Psichiatria* 14:541–77.

OSTWALD, W. 1922. *Die Farbenlehre*. Leipzig.

PETTER, G. 1956. Nuove ricerche sperimentali sulla totalizzazione percettiva. *Rivista di Psicologia* 50:213–17.

———. 1958. Osservazioni sulla trasparenza fenomenica. Pp. 183–86 in *Atti del 12° Congresso degli psicologi italiani*.

RUBIN, E. 1927. Visuell wahrgenommene wirkliche Bewegungen. *Zeitschrift für Psychologie* 103.

RUNGE, PH. 1810. *Farbenkugel*. Hamburg.

SCHÖNBERG, A. 1963. *Manuale di armonia*. Milan: Il Saggiatore.

TUDOR-HART, B. 1928. Studies in transparency, form and color. *Psychologische Forschung* 10:255–98.

WELLS, A. 1980. Music and visual color: A proposed correlation. *Leonardo* 13:101–7.